ADDAMS' APPLE

The New York Cartoons of **CHARLES ADDAMS**

Foreword by **SARAH M. HENRY**
Deputy Director and Chief Curator, Museum of the City of New York

Preface by **LUC SANTE**

Tee and Charles Addams Foundation

The Tee and Charles Addams Foundation's purpose is to interpret and share the artistic achievements of Charles Addams. Established in 1999 by his widow, Tee Addams, and H. Kevin Miserocchi, the private nonprofit organization supports exhibitions and programs developed from all works by Charles Addams, including the foundation's own collections and from its copyrights of the Addams oeuvre.

Pomegranate

PORTLAND, OREGON

SARAH M. HENRY is deputy director and chief curator at the Museum of the City of New York. Dr. Henry received a PhD in American History from Columbia University and a BA from Yale in History and Mathematics/Philosophy. She is the recipient of the Manhattan Borough President's History Visionary Award, is a member of the New York Academy of History, and serves on the board of the International Council of Museums' Committee on the Collections and Activities of Museums of Cities (CAMOC). In 2010, she curated *Charles Addams's New York* in collaboration with H. Kevin Miserocchi, and in 2016 curated the Museum's award-winning signature exhibition, *New York at Its Core* (2016).

LUC SANTE is the author of *Low Life*, *The Factory of Facts*, *Kill All Your Darlings*, and *The Other Paris*, among other books. An award-winning writer and Guggenheim Fellow, he teaches at Bard College in Annandale-on-Hudson, New York.

Pomegranate Communications, Inc.
19018 NE Portal Way, Portland, OR 97230
800-227-1428 pomegranate.com
sales@pomegranate.com

To learn about our newest titles and special offers from Pomegranate, please visit pomegranate.com and sign up for our newsletter. For all other queries, see "Contact Us" on our home page.

FRONT COVER: *Subway Hand*, from the *New Yorker*, 24 August 1987
BACK COVER: *Appearing Nightly*, from the *New Yorker*, 28 November 1983

Library of Congress Cataloging-in-Publication Data

Names: Addams, Charles, 1912-1988, artist. | Henry, Sarah M., writer of
 foreword. | Sante, Luc, writer of preface.
Title: Addams' Apple : the New York cartoons of Charles Addams / foreword by
 Sarah M. Henry, Deputy Director and Chief Curator, Museum of the City of
 New York ; preface by Luc Sante
Other titles: Cartoons. Selections
Description: First. | Portland : Pomegranate, [2020]
Identifiers: LCCN 2019035312 | ISBN 9780764999369 (hardcover)
Subjects: LCSH: American wit and humor, Pictorial. | New York
 (N.Y.)--Caricatures and cartoons. | New York (N.Y.)--Social life and
 customs--Caricatures and cartoons.
Classification: LCC NC1429.A25 A4 2020 | DDC 741.5/69747--dc23
LC record available at https://lccn.loc.gov/2019035312

Item No. A290
Designed by Stephanie Odeh
Printed in China

30 29 28 27 26 25 24 23 22 21 11 10 9 8 7 6 5 4 3 2

Contents

Foreword

It was a striking sound in the halls of the Museum of the City of New York—laughter bubbling up from every corner of the room. It was the spring of 2010 and MCNY's first Charles Addams exhibition in more than half a century—*Charles Addams's New York*—was on view. Each day, the gallery erupted in a chorus of chuckles, snorts, giggles, and guffaws as visitors decoded sly messages in deceptively subversive scenes of life in everyday New York, Addams-style.

This book, like that exhibition, brings together many cartoons that Charles Addams set in his adopted hometown over the course of his long career in New York City. Appropriately, the connection between Addams and MCNY has deep roots—all the way back to 1948, when the museum's pioneering curator of prints, Grace Meyer, took the initiative to ask the cartoonist to donate an image he had published in the *New Yorker* (the subject: a therapist counseling a Native American client about how to deal with the enduring trauma of selling Manhattan to the Dutch). Addams applauded Meyer for her "impertinence" and sent the artwork. Eight years later, MCNY staged the artist's first solo museum exhibition. And over the course of the next decade, Addams donated more than sixty of his artworks—both preparatory sketches and finished drawings—to the collection.

The connection between Addams and the Museum of the City of New York was a natural one, because Addams' New York cartoons collectively provide a glimpse—albeit a deliciously idiosyncratic one—into the institutions and mindsets that define the city's culture. The cartoons capture the reliable mainstays of the New York experience, from museums and zoos to department stores, subways and buses, apartments and streets—even the Automat. But his is also a city in which surprising, unlikely, and incongruous juxtapositions produce a memorable blend of the real and surreal. New York proves the perfect subject for Addams, as the blasé-ness of New Yorkers meets the anything-can-happen quality of the city's streets.

And anything sure can happen in an Addams cartoon! Giant hands beckon from subway entrances, octopi grab passersby from manhole covers, and the ghoulish characters who would later become conjoined as the Addams Family pop up in the streets, buses, and other public spaces of the teeming city. As Edward Rothstein wrote in his March 4, 2010, *New York Times* review of the exhibition, we "find in Addams's city a kind of theater: on sidewalks and in public spaces the most extraordinary sights proliferate, and the commonplace turns extreme."

Addams also captures the physical city with loving care. His passion for depicting the cityscape went back to his days as an art student. He enrolled at the Grand Central School of Art, which flourished from the 1920s into the 1940s on the upper floors of New York's storied railroad terminal. His biographer, Linda Davis, recounts in *Chas Addams: A Cartoonist's Life* that the young Addams became fascinated with observing the city, taking off from school to ride a double-decker bus and draw the details of New York's architecture. That careful attention to place informed his work for the rest of his career. The artist also transforms the city itself into a character in his work: in Addams' hands, New York City and its buildings, streets, landmarks, and skyline literally take on a life of their own.

The details and specificity of his urban settings are not just décor. They strategically add to his jokes by making a world so complex that your eye has to search for what is awry. Addams' humor often takes a moment to sink in precisely because the apparent normality and solid architectural presence of his cityscapes offset the abnormality of the events he places there. As Addams scholar Iain Topliss argues in *The Comic Worlds of Peter Arno, William Steig, Charles Addams, and Saul Steinberg*, the realism makes the juxtaposition of the unexpected details of his off-kilter scenarios all the more jarring and thus all the more memorable—and funny. Addams' *New York Times* 1988 obituary quoted art critic John Russell praising the artist for "the calculated ordinariness that lures us into a trap."

But more than anything, Addams' New York cartoons are about his New Yorkers. These include homey residents and gray-flanneled office workers alongside macabre spirits, blending the ordinary with the extraordinary. As a group they are admittedly a very white, apparently middle-class, classically midcentury bunch: men are corporate drones in suits; women are secretaries, wives, or cleaning women; even the Family lives in a sprawling house in the suburbs (by implication Addams' hometown of Westfield, New Jersey) from which they make excursions into New York City. Addams touches on such quintessentially midcentury *New Yorker* themes as the war of the sexes, the conformity of the workplace, the analyst's couch, or the pretensions of high society, albeit recast through his own warped take on the world.

The situations that these New Yorkers encounter may be surreal, but in many ways they channel the preoccupations of their era. Addams revels in poking gentle fun at the self-important bosses, the briefcase-toting "little men," the well-put-together secretaries, the steadfast and often jaded cleaning women. A host of indistinguishable (presumably gray-flanneled) men seated at a bar flummox the barkeep with a request for "the usual." Elsewhere, the cartoonist's fascination with windup people—big and small—echoes the zombie obsession of the 1950s. Urban isolation makes its appearance as a valentine is slipped under a barricaded New York door. And some images even seem to resonate with the anxieties of our own times: a briefcase populated by a miniature meeting-in-progress is comically evocative in the days of mobile tech. Soybean sandwiches in multiple meat flavors; a water tower for rent as a residence; even the "channel changing" window view doesn't seem that farfetched today. And Addams' penchant for depicting a flooded, melting city seems eerily prescient.

The cartoons in this volume capture New York as Addams lived and reimagined it. As he claimed, "I left a record of my times" (although they were evidently rather strange times). One can only imagine, and perhaps yearn for, what he would have made of our own accelerated, social media driven, rapidly changing city. Surely his New Yorkers would have taken it all in stride.

—Sarah M. Henry
Deputy Director and Chief Curator,
Museum of the City of New York

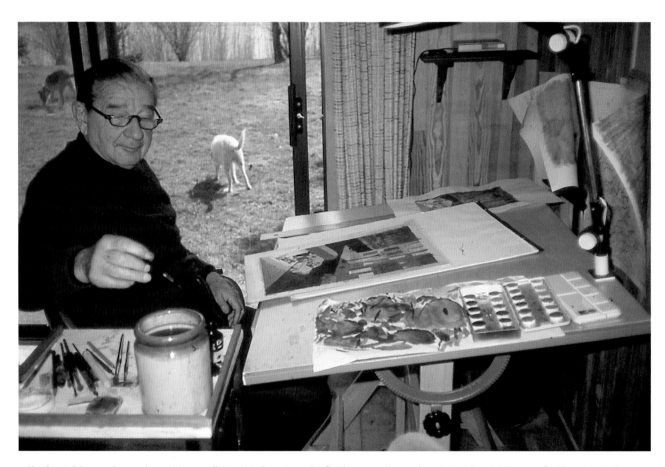

Charles Addams in his studio in Water Mill, New York, putting the finishing touches on his 31 October 1983 cover for the *New Yorker* magazine (see page 59).

Preface

As new immigrants to the United States in 1960, my family and I fetched up for a time in Westfield, New Jersey, where we lived in a Victorian mansion that had been cut up into small apartments. Seemingly every house in the neighborhood—maybe every house in town—was a Victorian mansion. They were as vast as castles, as fragile as shacks (being made of wood), and freighted with the gloom of an implied history that went back maybe three-quarters of a century. Paint jobs and sparkling bathroom fixtures did nothing to dispel their labyrinthine mysteries. I hadn't yet heard the term American Gothic, and I certainly didn't know that a few blocks away lived Charles Addams, who understood better than anyone the hauntedness of those houses and could perceive the silliness of their ghosts.

Charles Addams occupies a unique place in American culture. He firmly stands at the intersection where Edgar Allan Poe tips his hat to Smokey Stover, Shirley Jackson reads Lewis Mumford's palm, Edward Hopper and Alfred Hitchcock discuss home renovations, and Booth Tarkington flips through *Famous Monsters of Filmland*. No one else could have braided together all those strands. Addams' landscape did include the modern city, but his heart was in the leavings of what Mumford called The Brown Decades: the mansard-roofed, grand-staircased, high-windowed houses that looked haunted even when new; the cemeteries with their broken columns and weeping cherubs; the chandeliers and gazebos and wrought-iron fences and four-story birdcages of the time when the nation was becoming a world power while still in mourning for the Civil War. It was a time when wholesale druggists and lampshade manufacturers tried to will themselves into constituting an aristocracy, complete with medieval ancestry and unquiet revenants.

That dead Victorian past endured well into the swinging sixties, and the dissonance was notable: think of the Manchurian Candidate landing in the midst of the ladies' garden club meeting, or the haunted Shakespearean John Carradine turning up in *The Astro-Zombies* (1968). *The Addams Family* television series embraced that dissonance. Gomez and Morticia, who had appeared unnamed in Addams' cartoons for years before television came calling, were revealed as beatniks, sufficiently hep to dwell in the verdigris past and the dayglo present at the same time without discomfort—without even acknowledging the contradiction. And they are fundamentally gentle people, as, it would seem, was Addams himself. His cartoons, which depend on the trappings of horror for their humor, are cushioned by mundane rituals, buttressed by good manners, garlanded with innocence. In my single favorite cartoon, the character eventually known as Uncle Fester laughs while the rest of the movie audience weeps silently, but his laughter isn't knowing or menacing; it is filled with childlike wonder and delight. Charles Addams, likewise, had a love of life so capacious that it extended to the leaving of it.

—Luc Sante

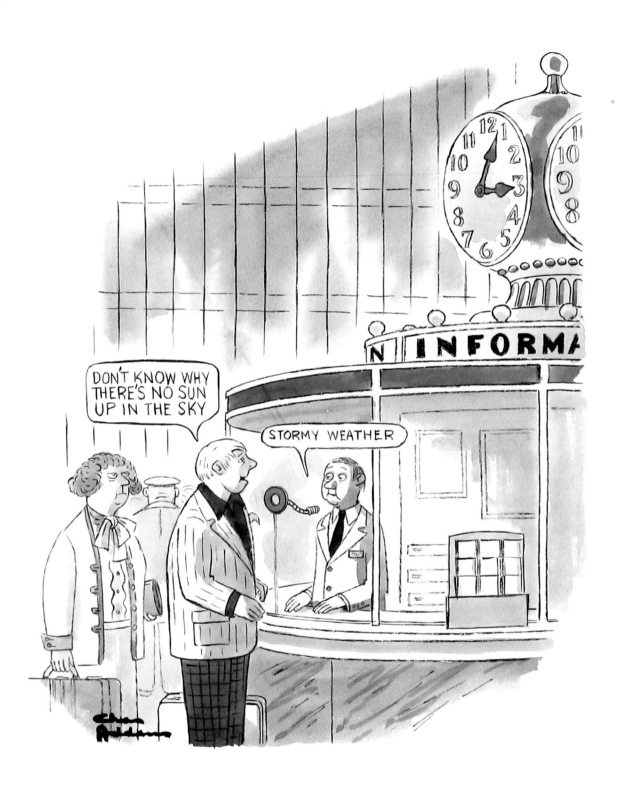

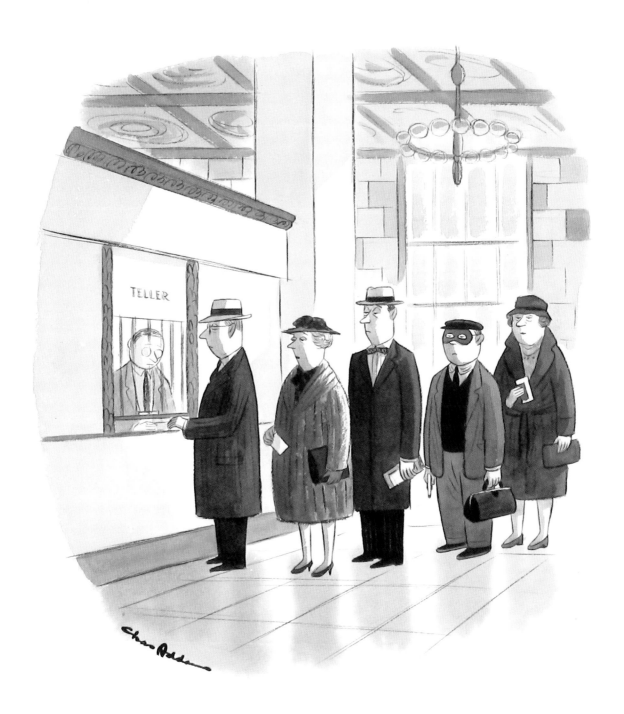

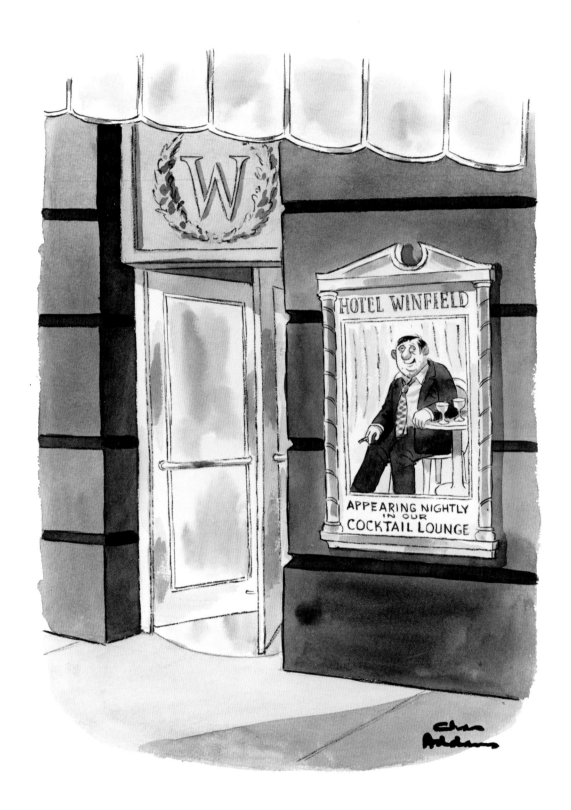

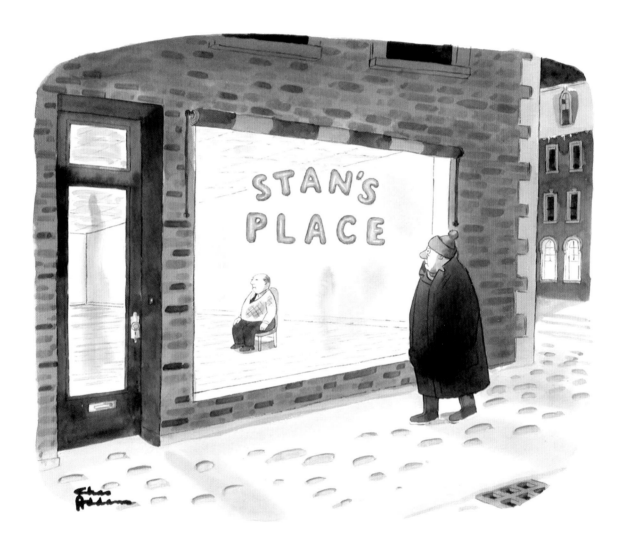

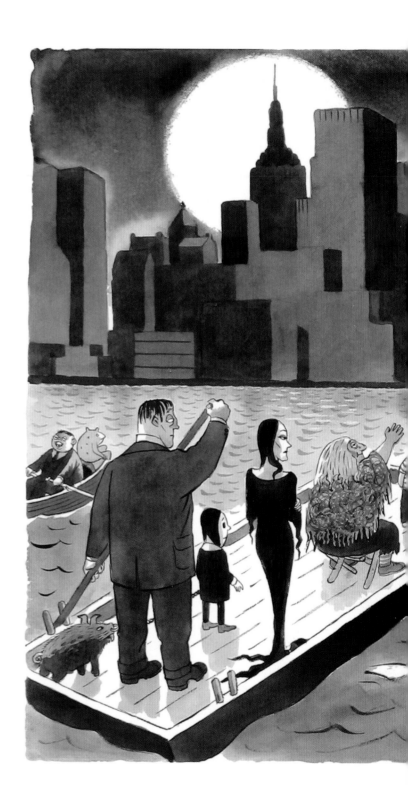

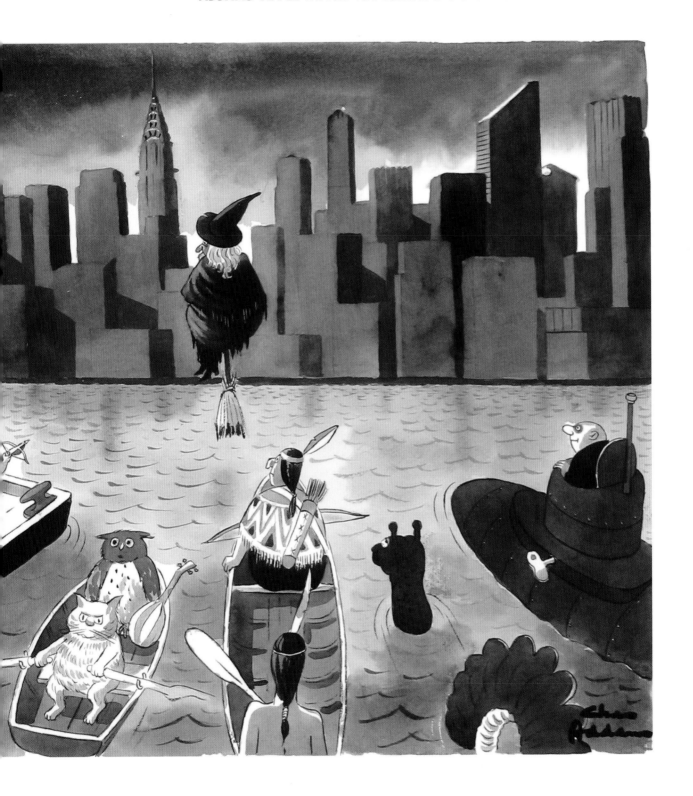

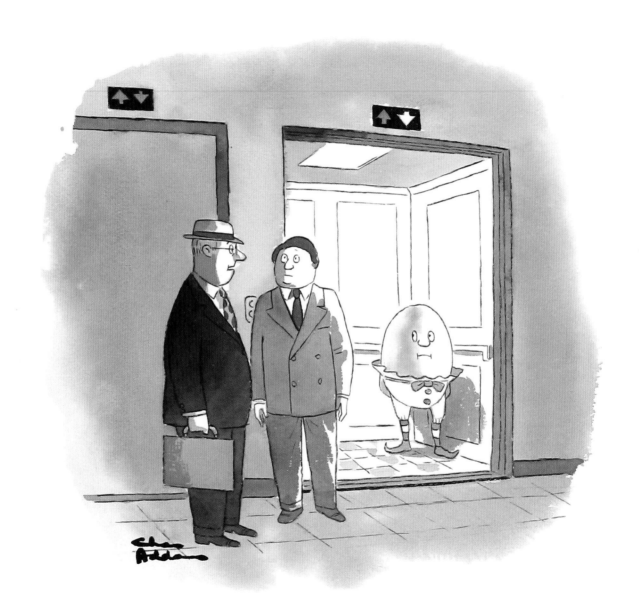

"I think I'll wait for the next elevator."

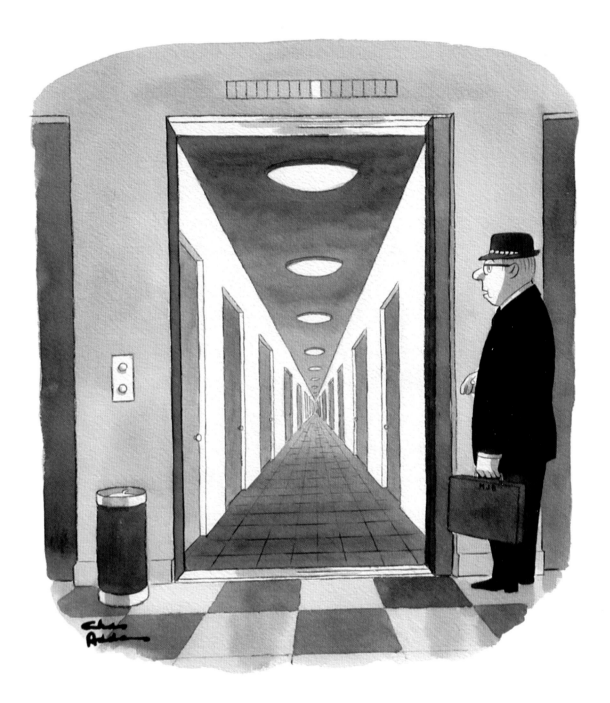

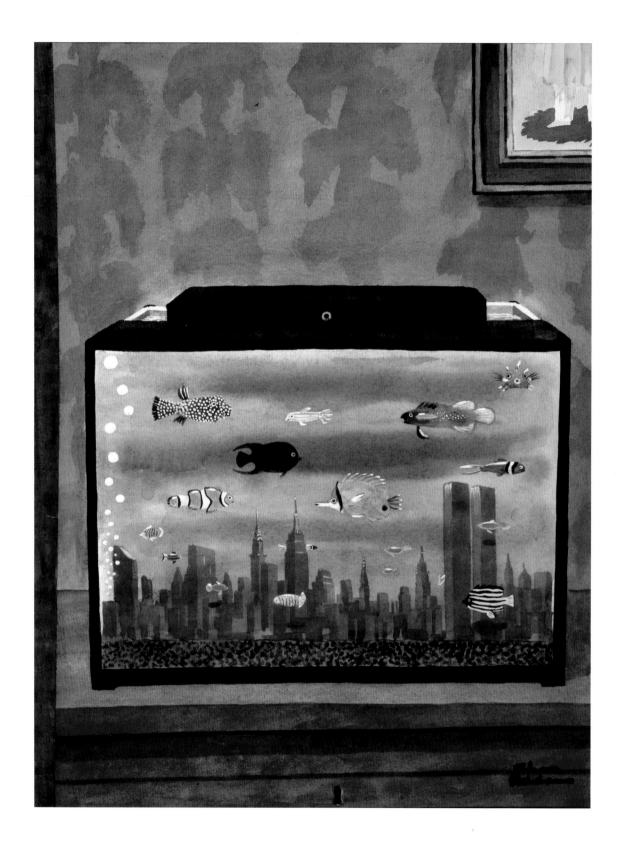

16

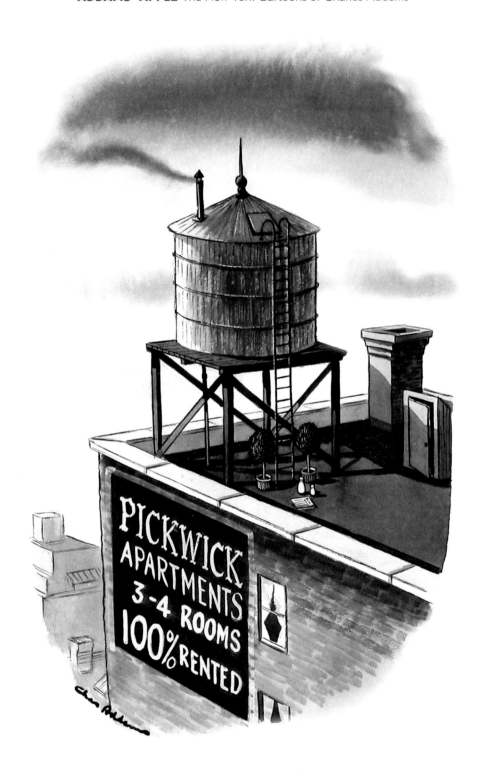

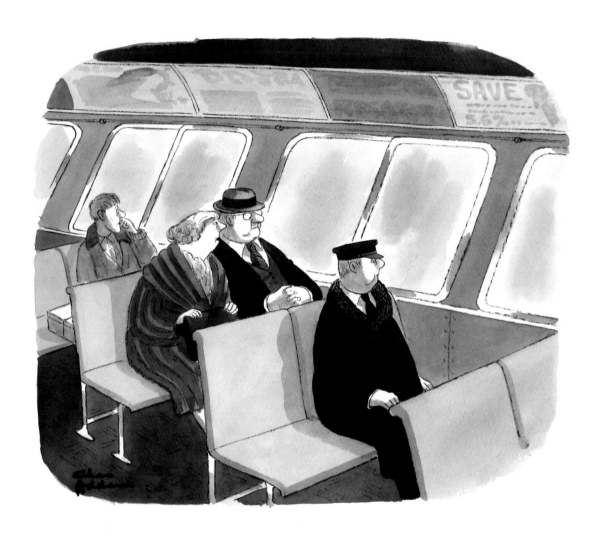

"Now that we've given up the car, I wonder if we still need Orkins."

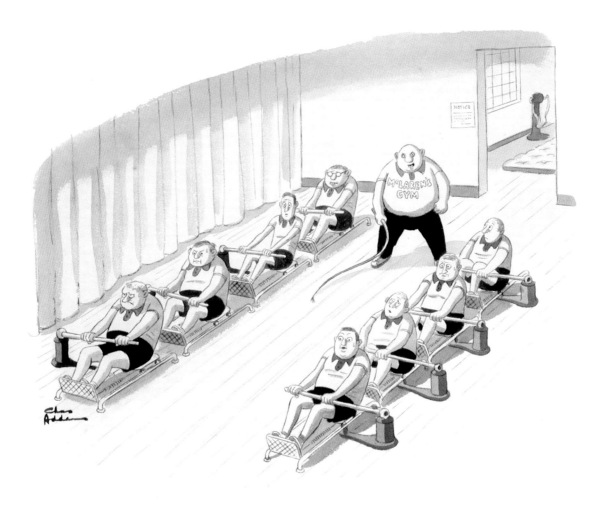

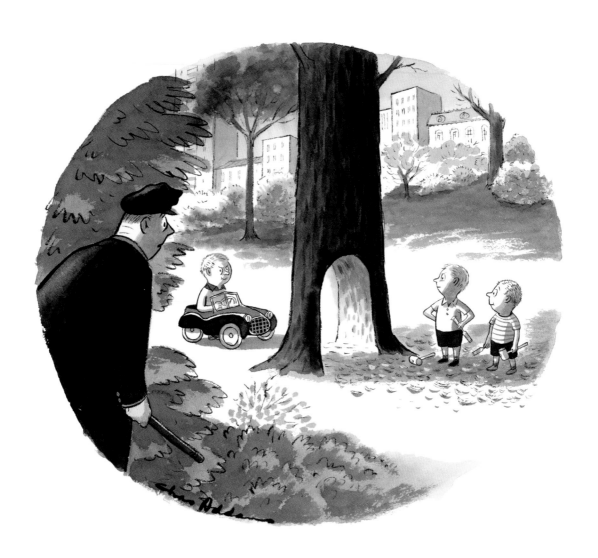

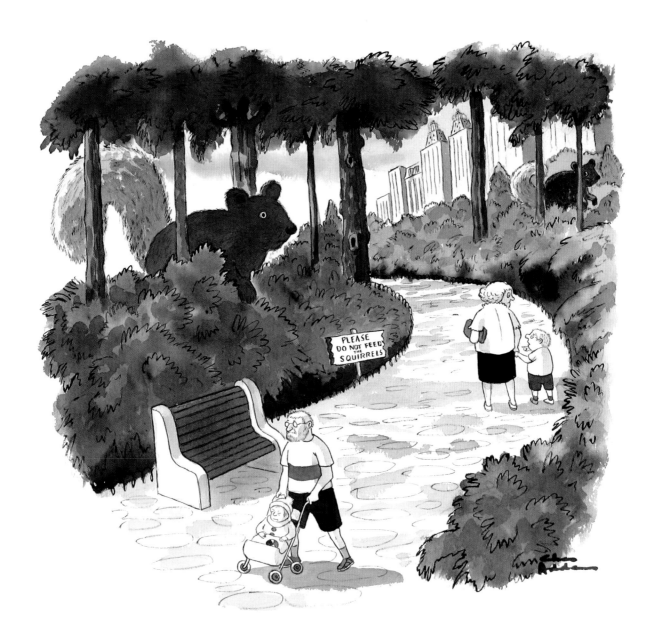

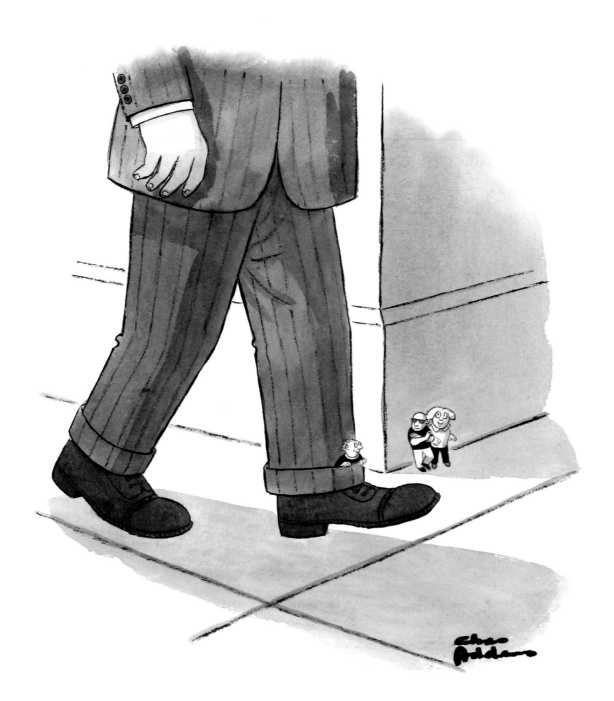

"Oh, great! Cuffs are back."

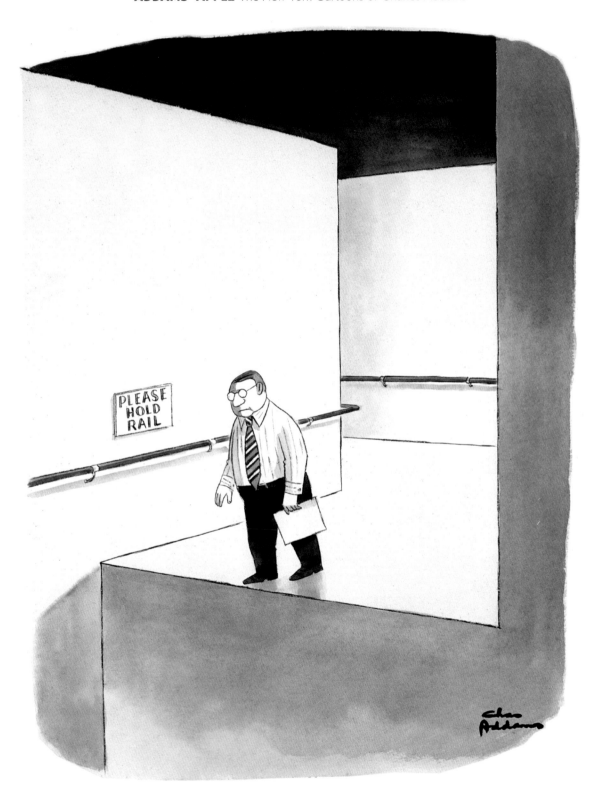

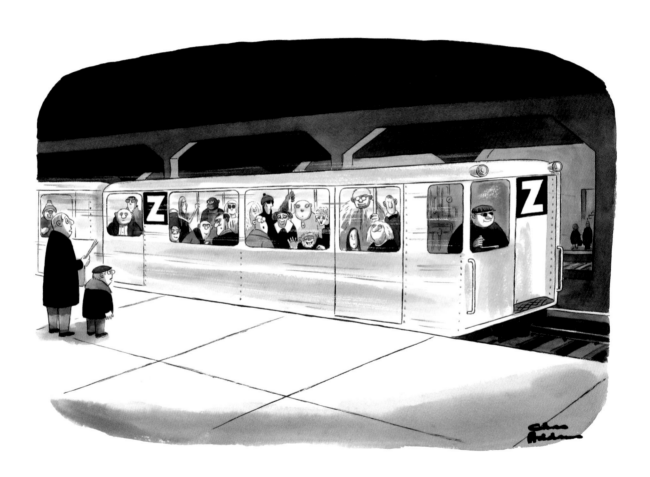

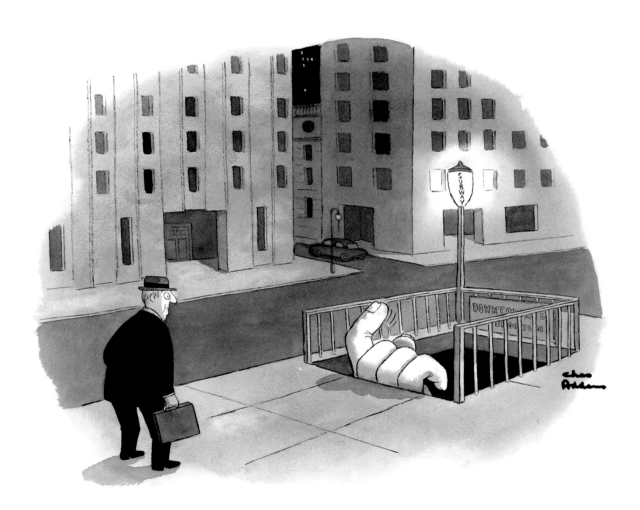

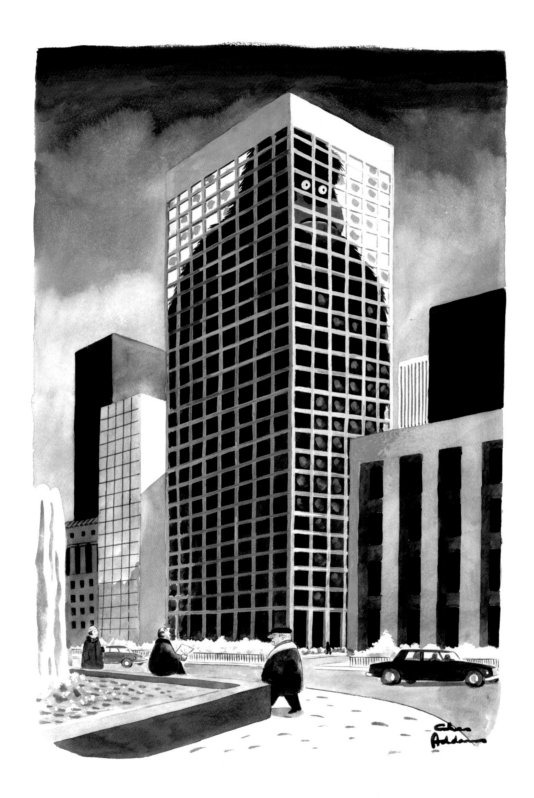

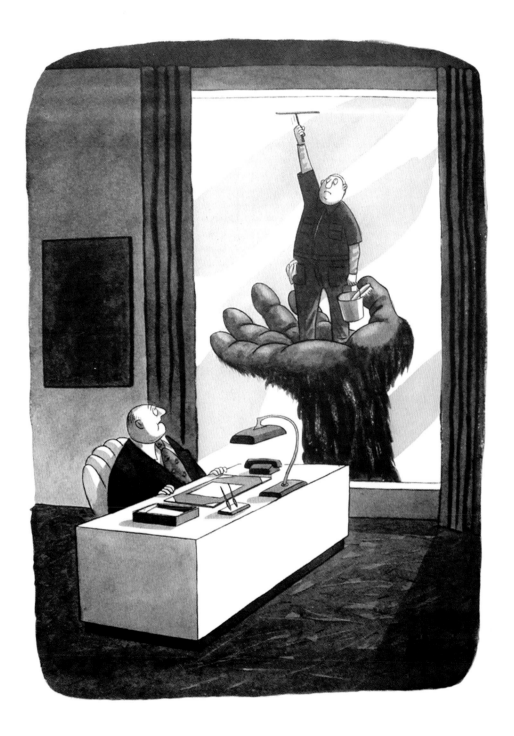

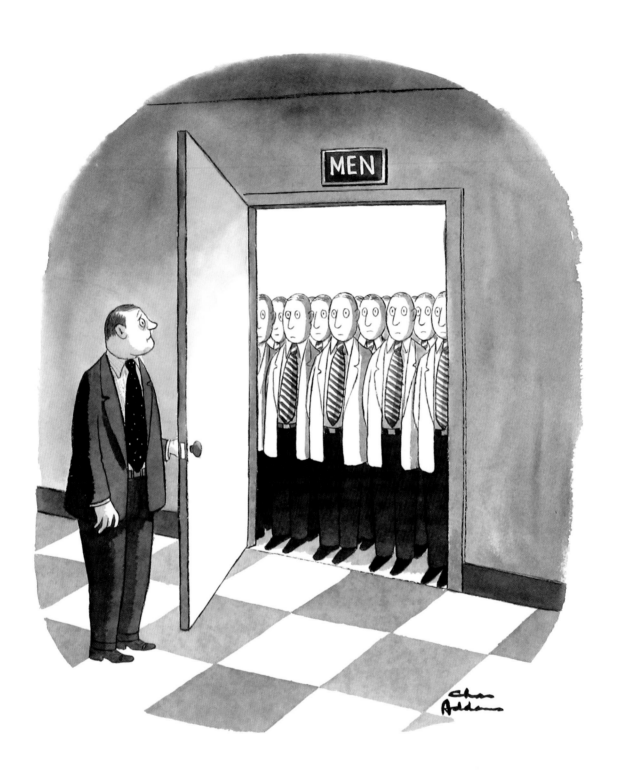

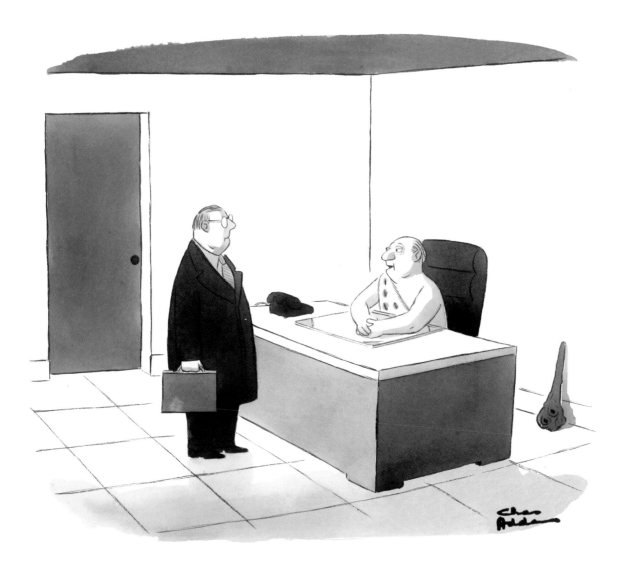

"Oh, nothing much, Frank. What's new with you?"

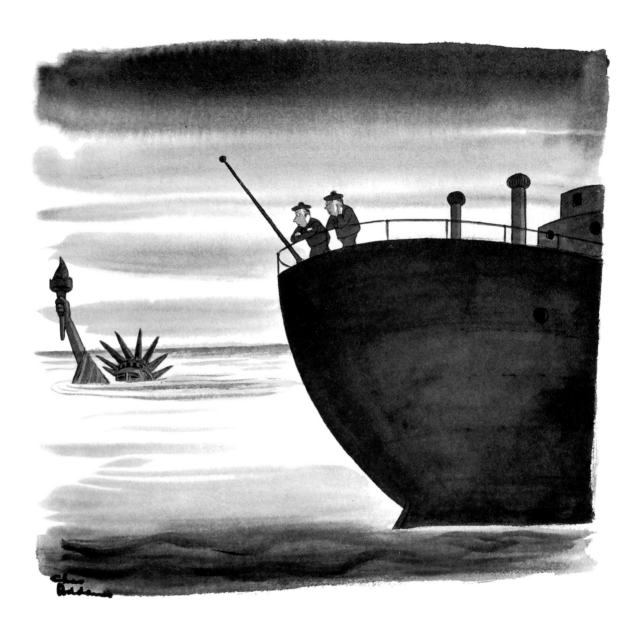

"High tide, I see."

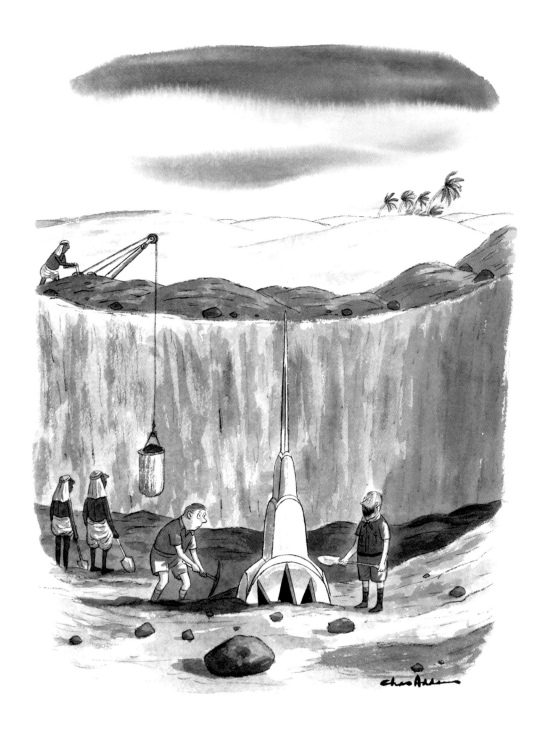

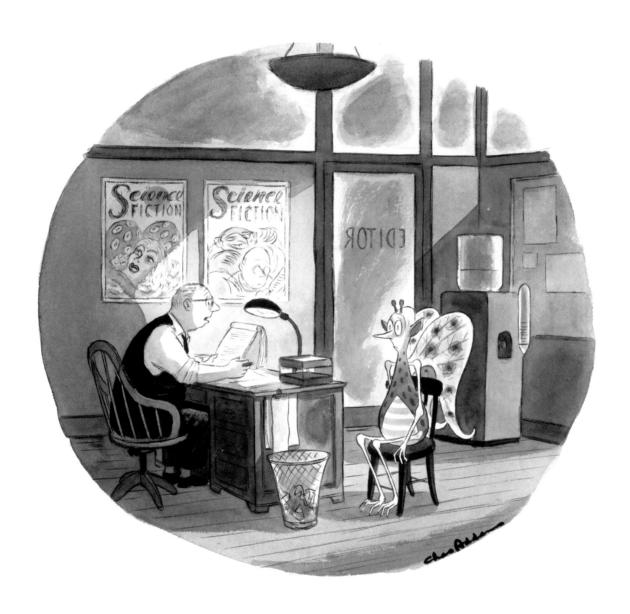

"It's very interesting, but I'm afraid we only publish science fiction."

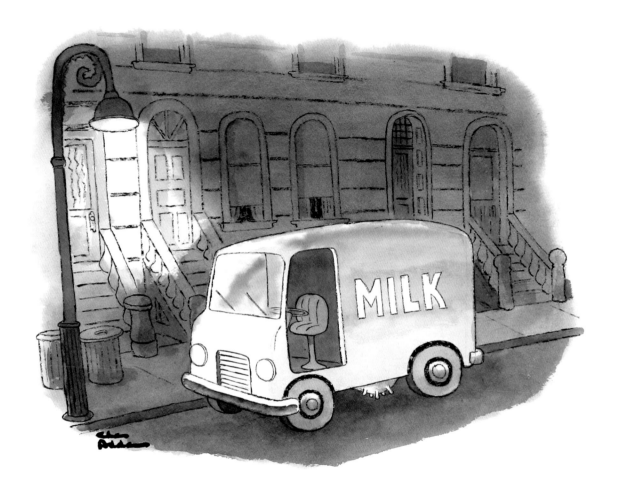

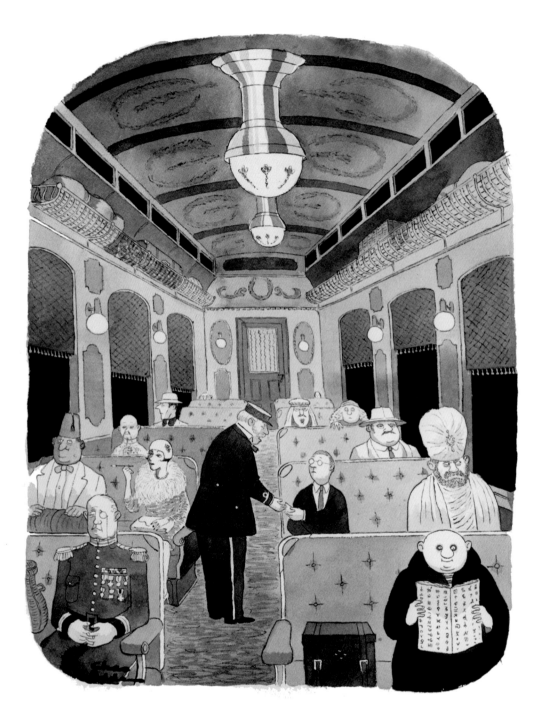

"No, this is not the 12:38 to Bridgeport."

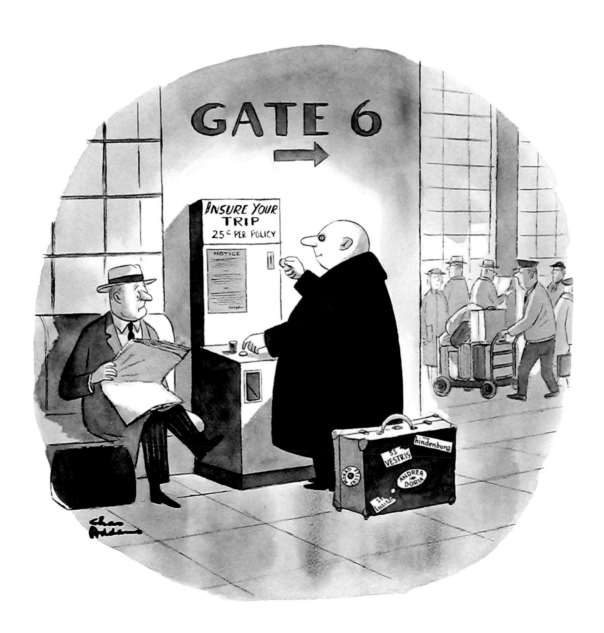

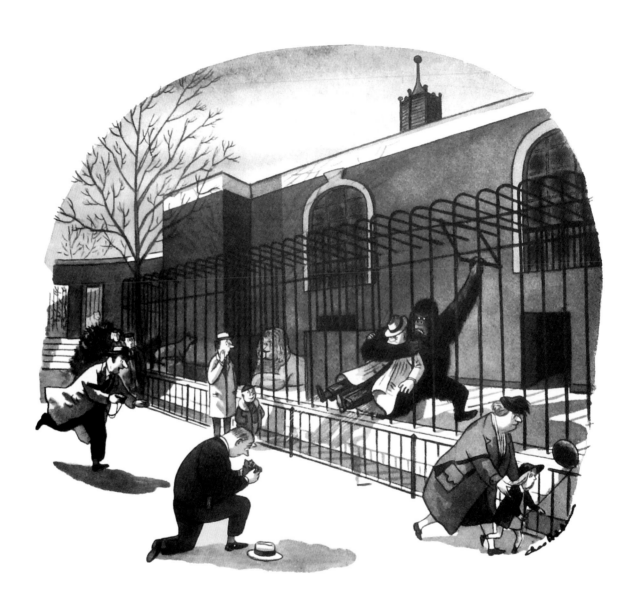

"What light you giving it?"

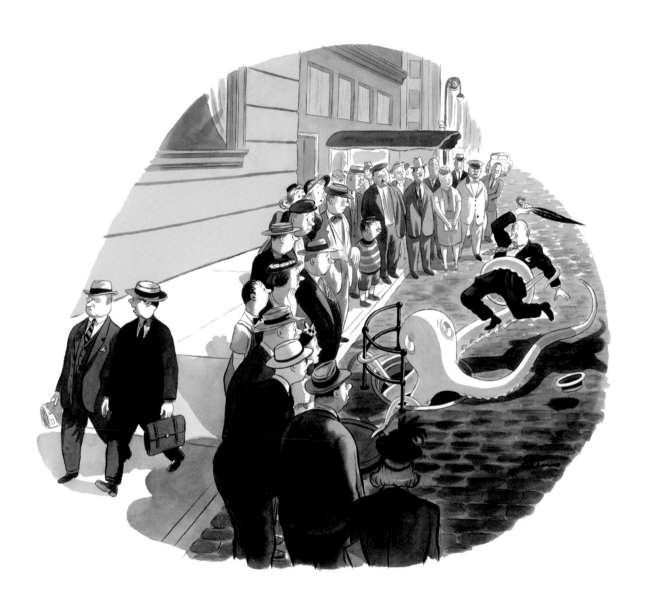

"It doesn't take much to collect a crowd in New York."

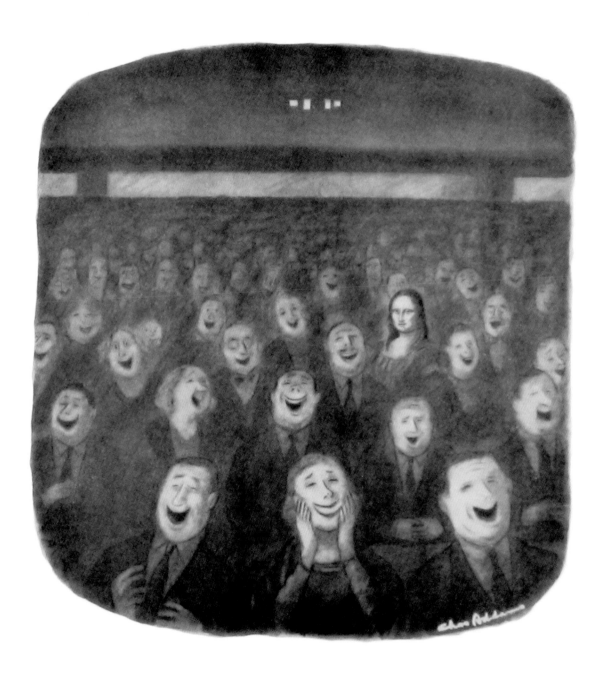

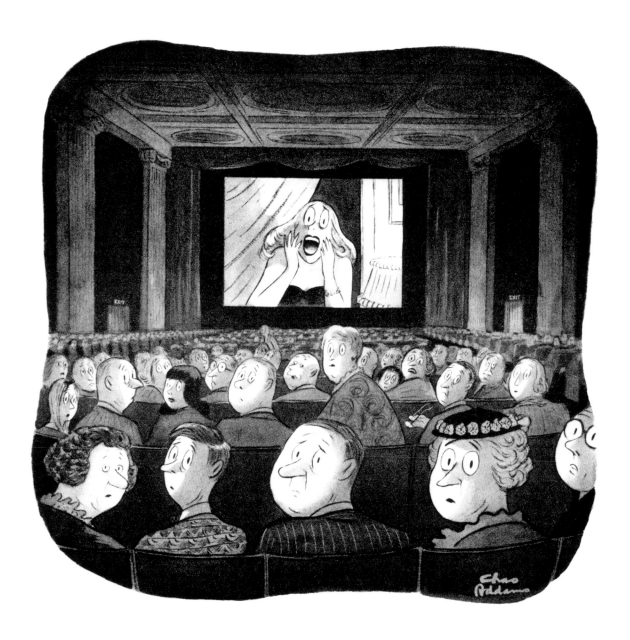

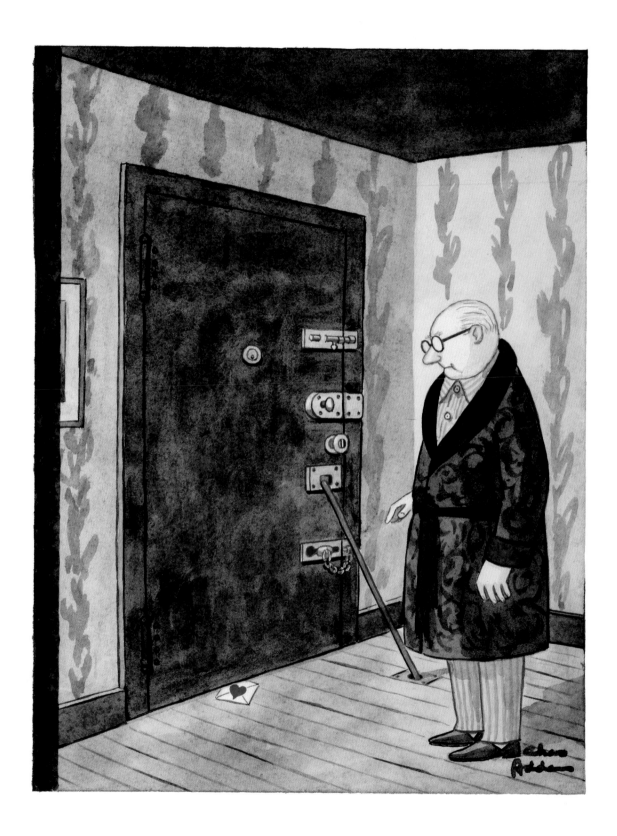

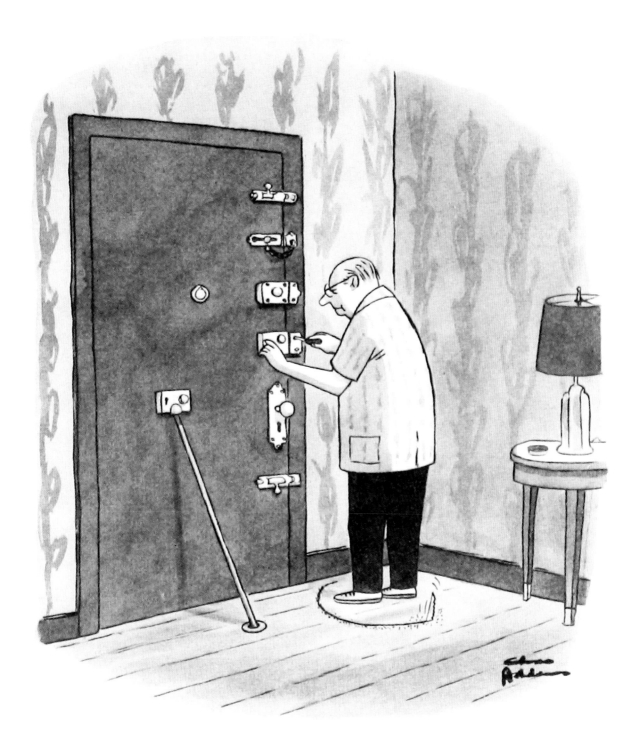

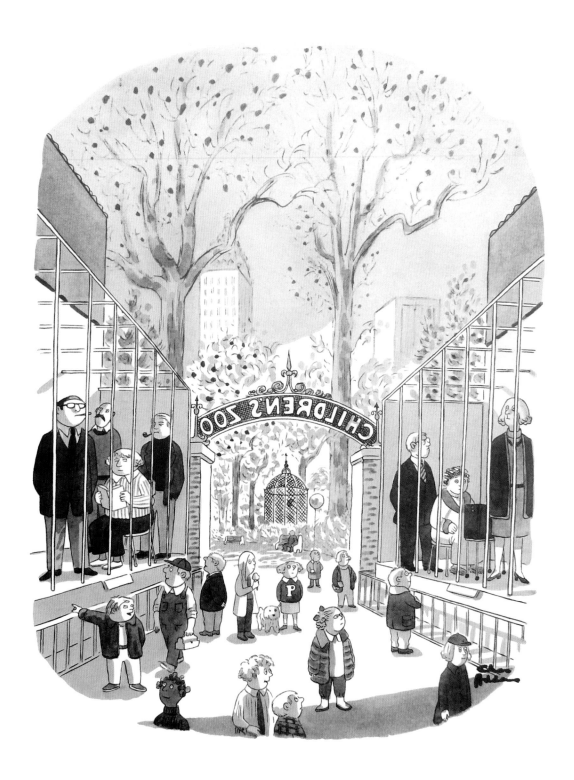

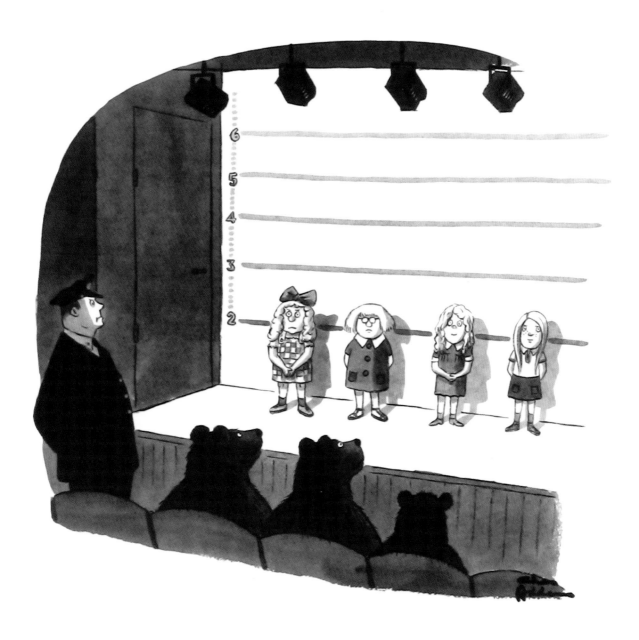

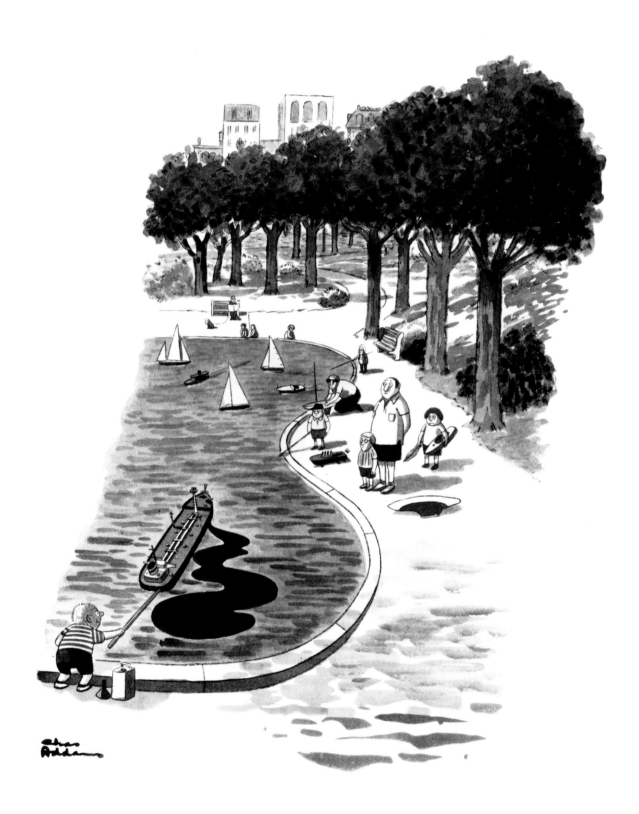

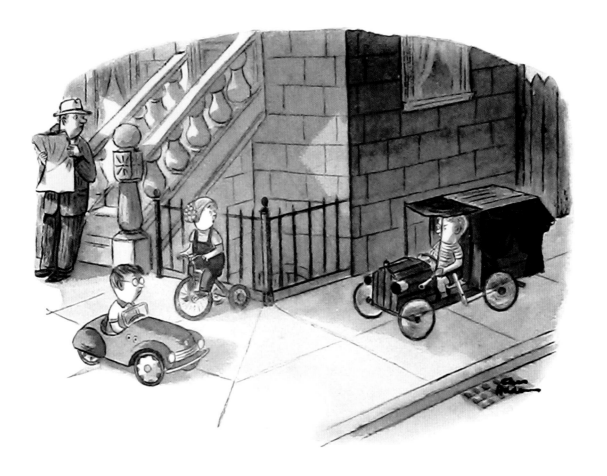

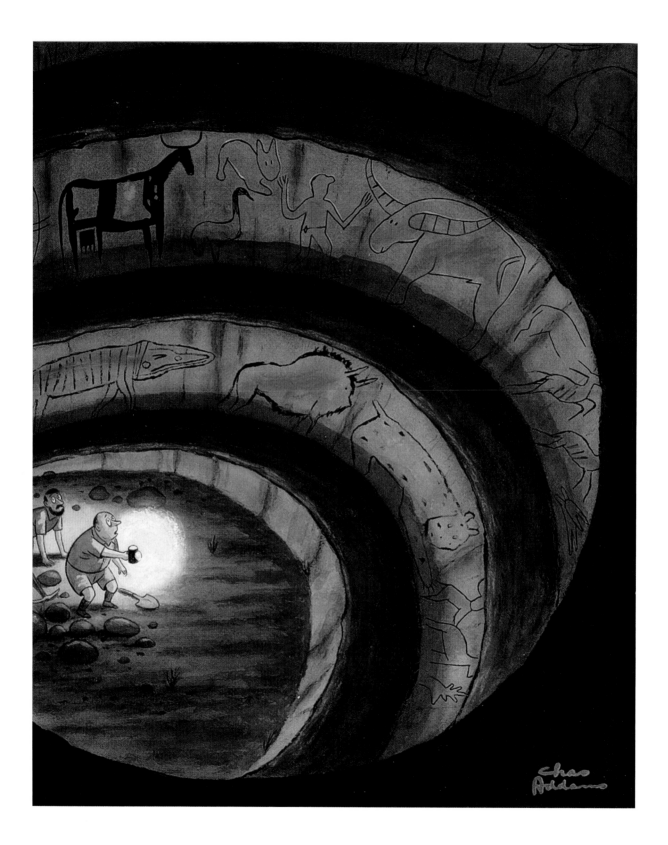

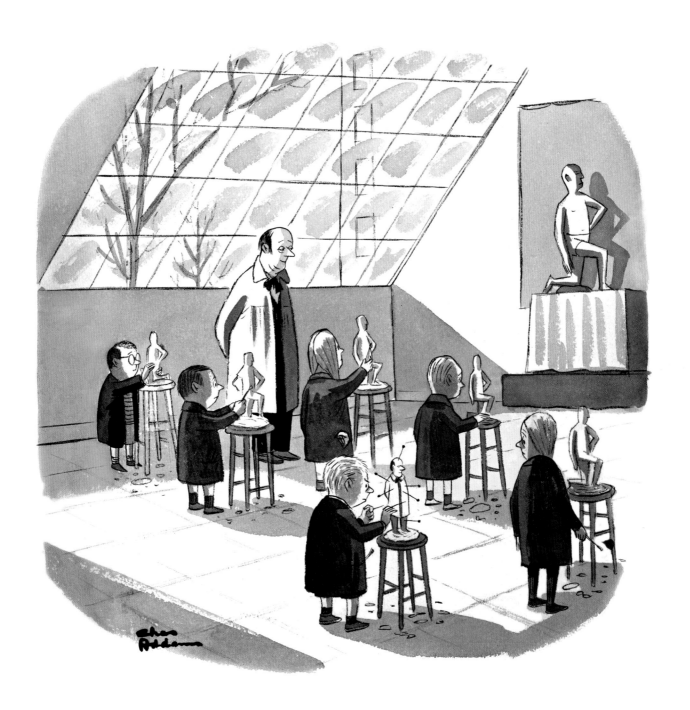

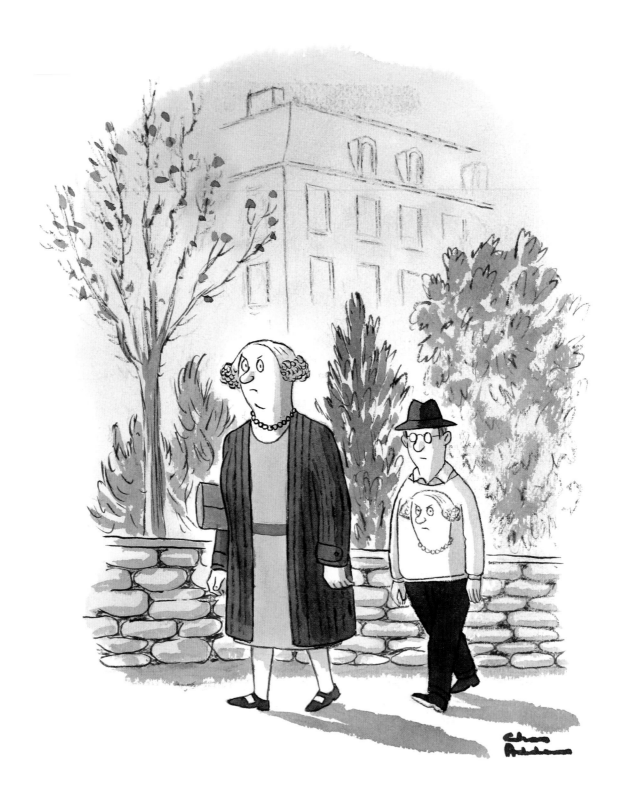

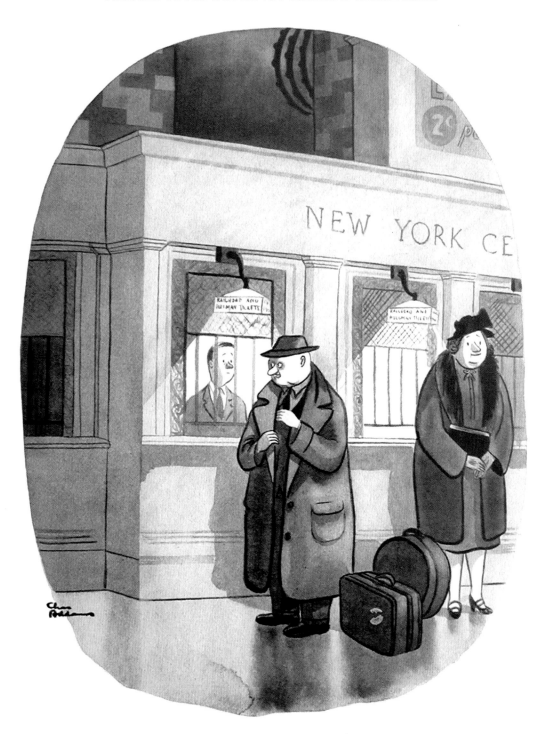

"A round trip and a one-way to Ausable Chasm."

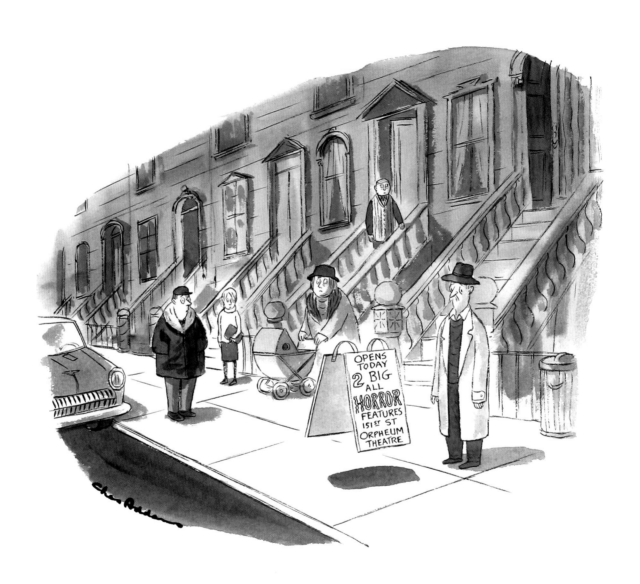

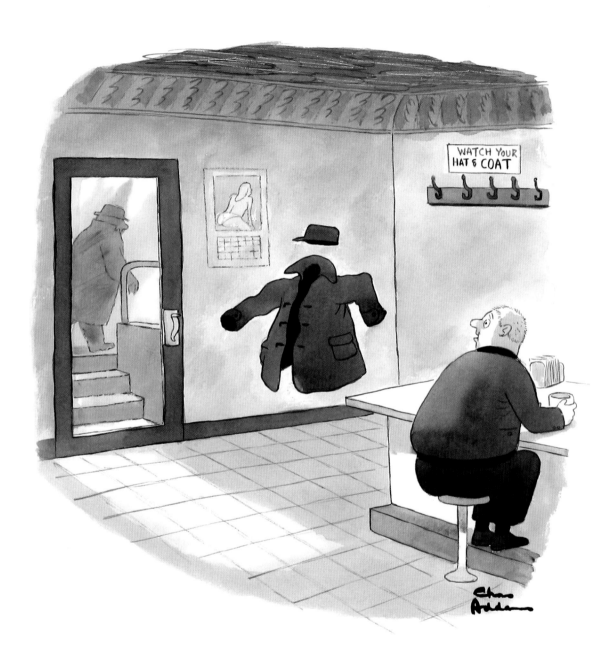

1

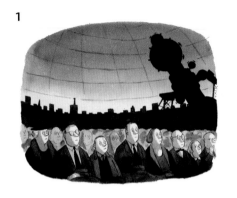

2

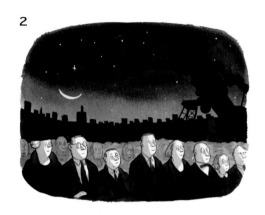

3

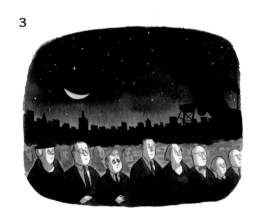

4

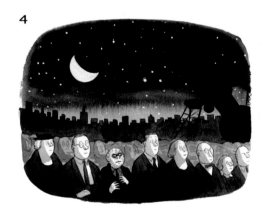

5
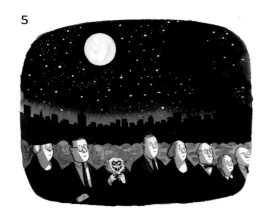

6
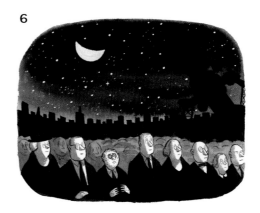

7
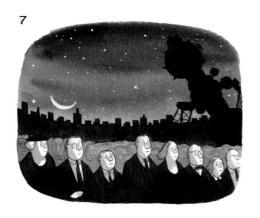

8
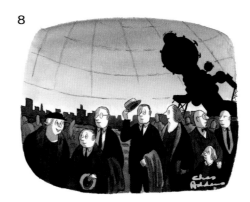

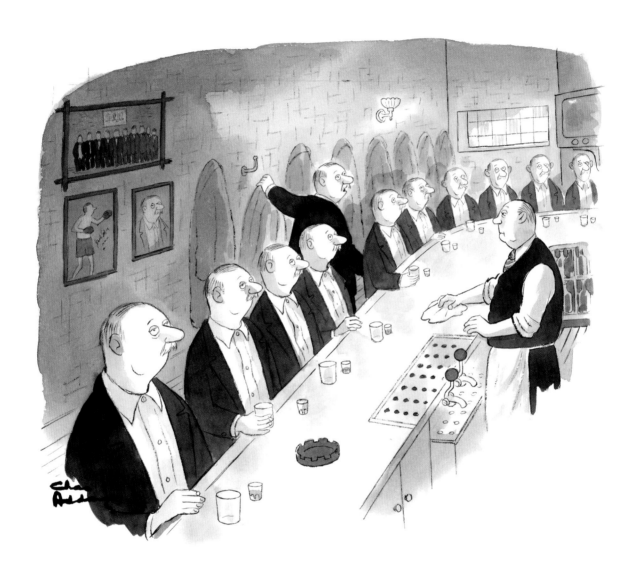

"The usual."

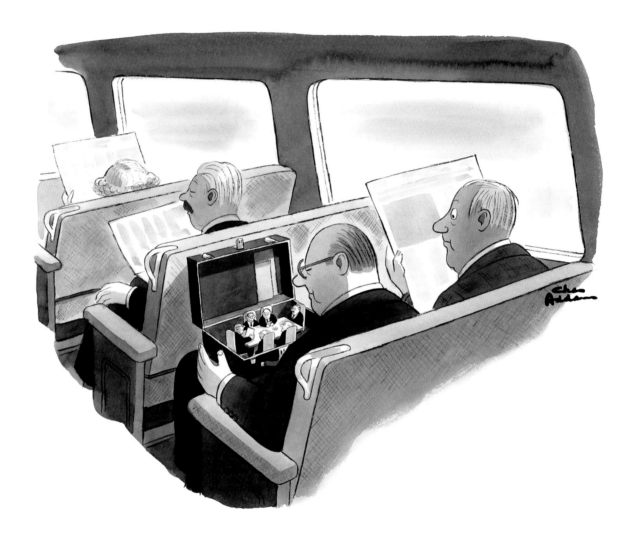

"Miss Sargent! What do you know about plants?"

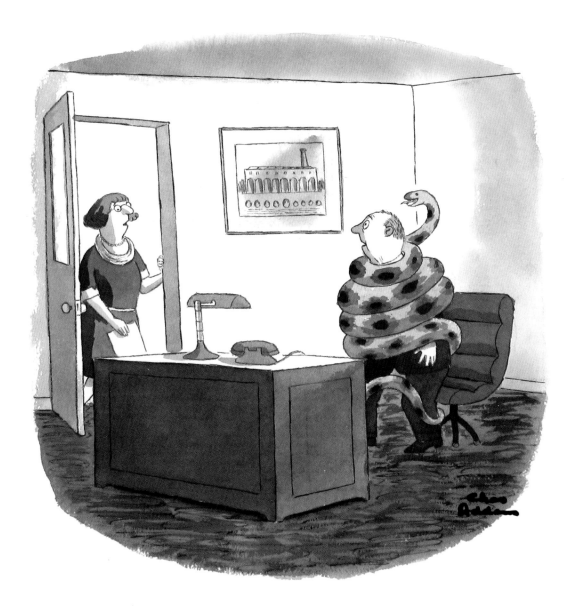

"Miss Fleming, would you mind dialing 911 for me?"

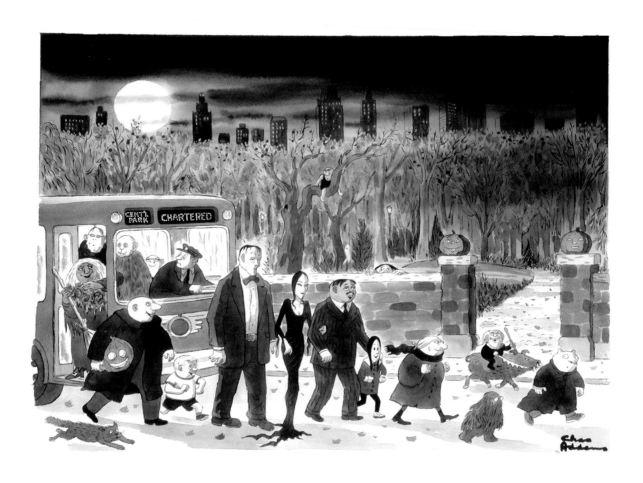

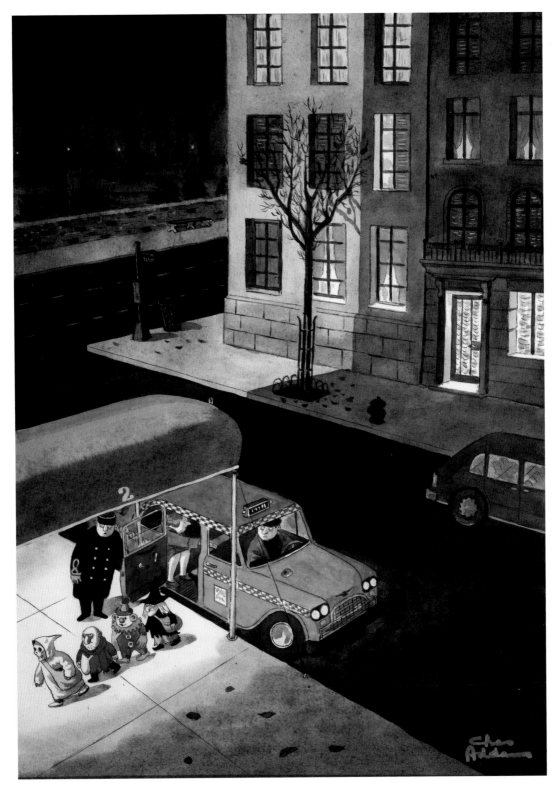

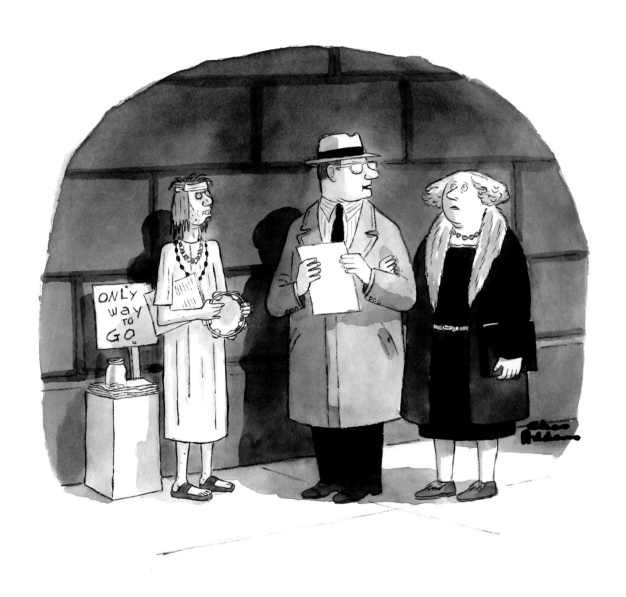

"You go home without me, Irene. I'm going to join this man's cult."

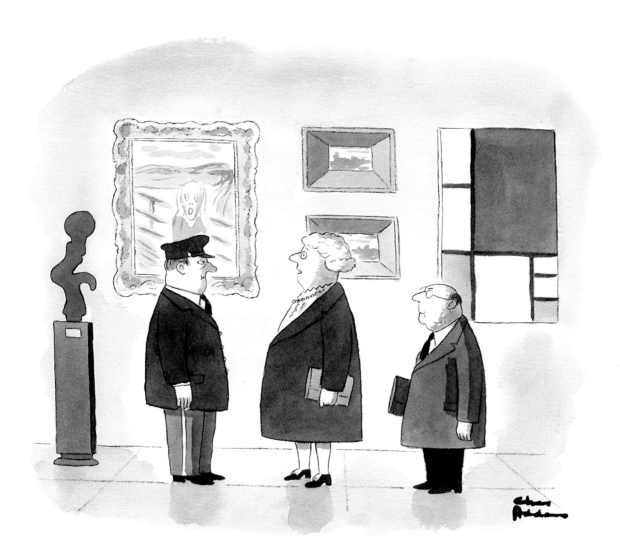

"Do you have anything here that a certified public accountant might enjoy?"

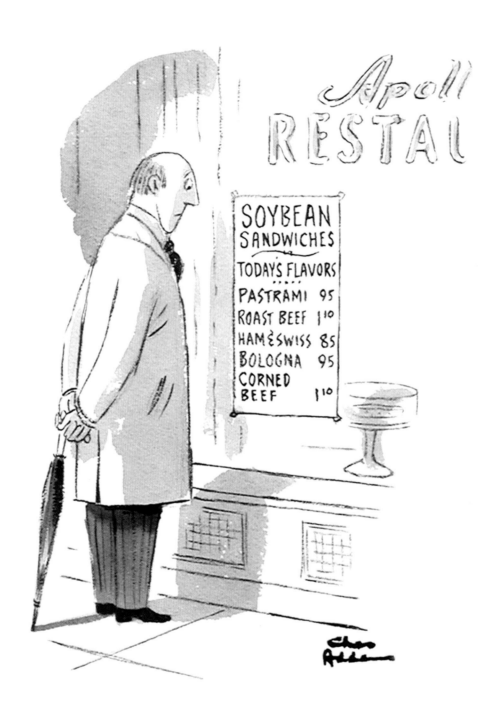

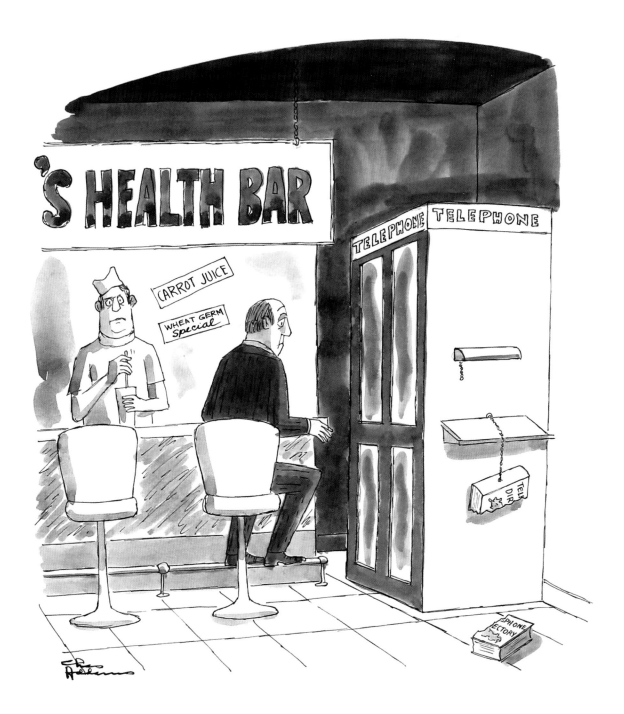

"Blunt instruments?"

"I don't know his sleeve length, but his neck is about like that."

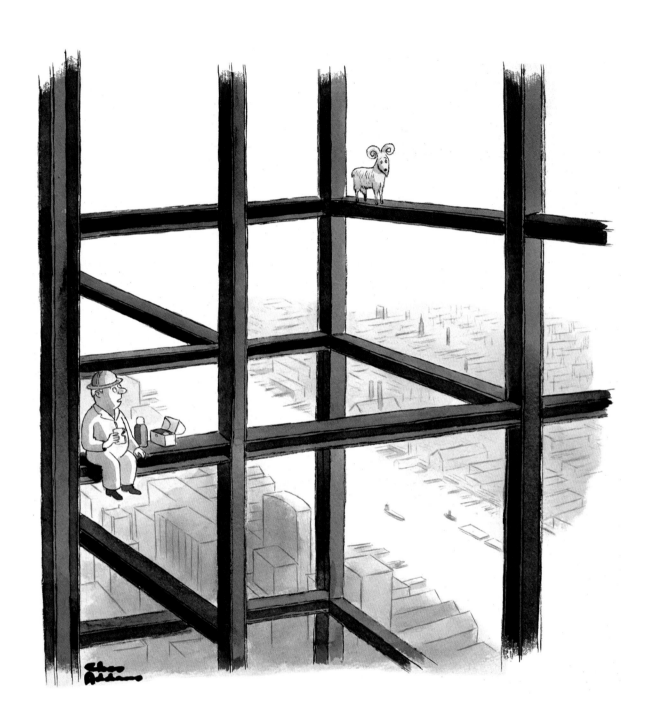

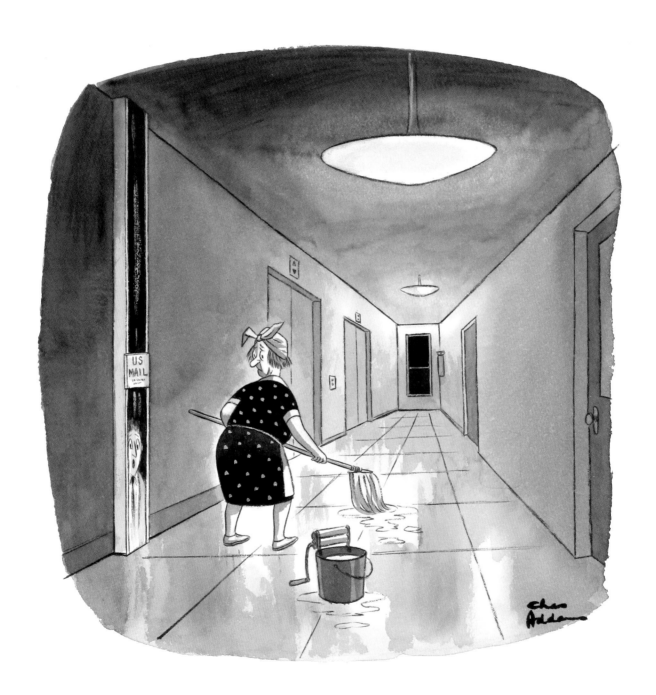

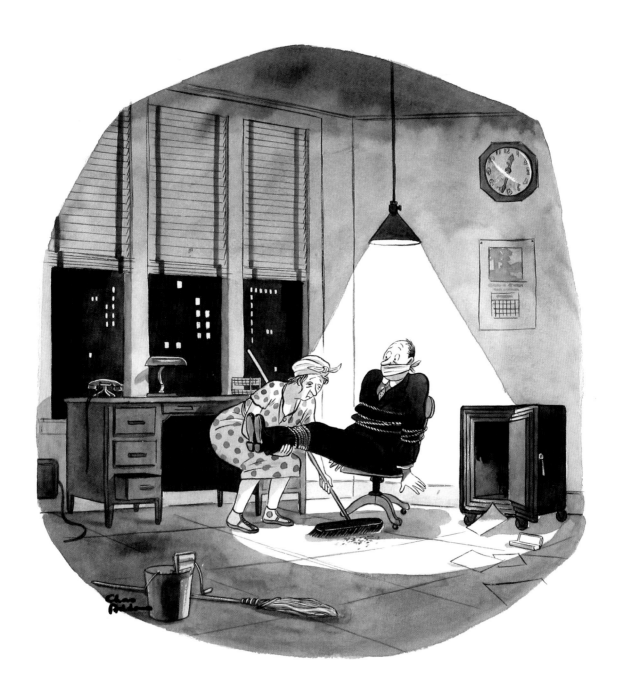

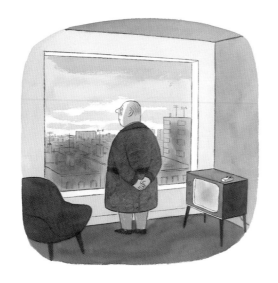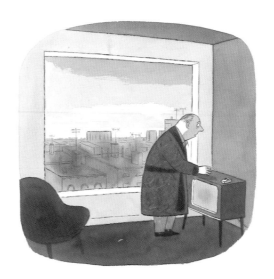

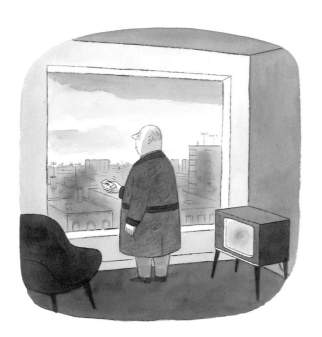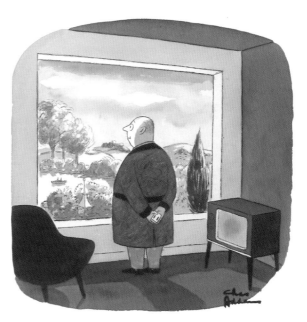

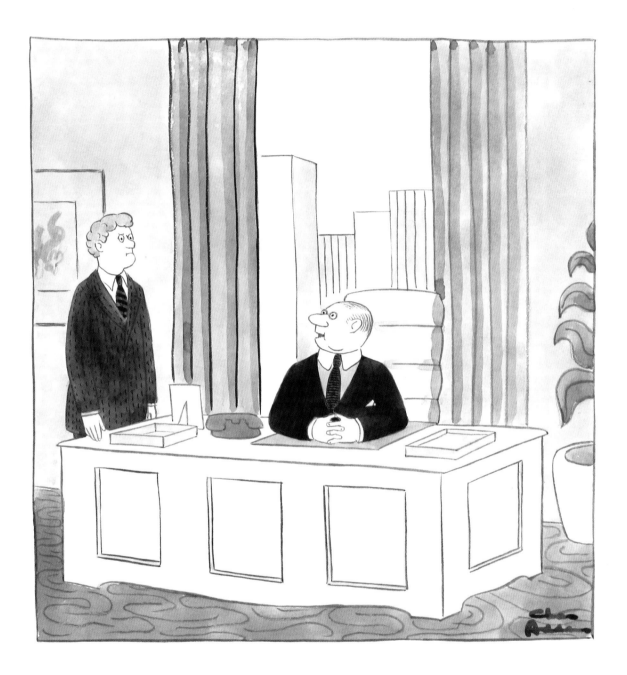

"I admire your honesty and integrity, Wilson, but I have no room for them in my firm."

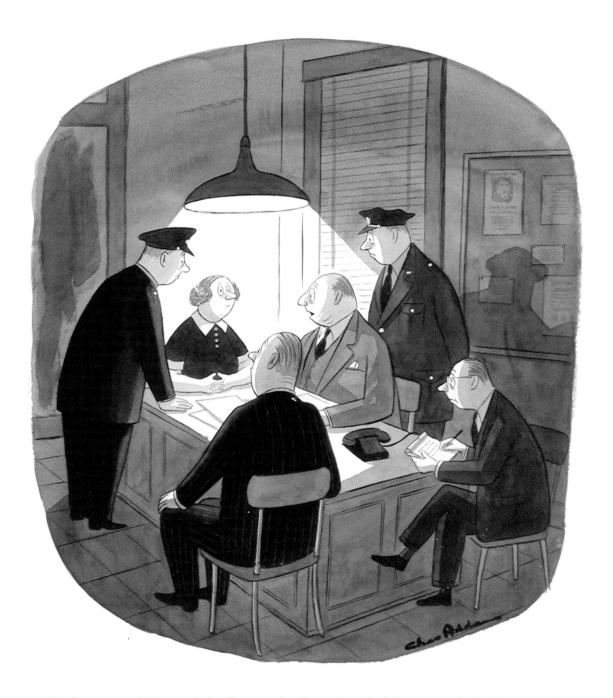

"So far, so good. You took the flour and milk, and added the sugar, the baking powder, and the vanilla. You folded in the egg whites. Then what did you do?"

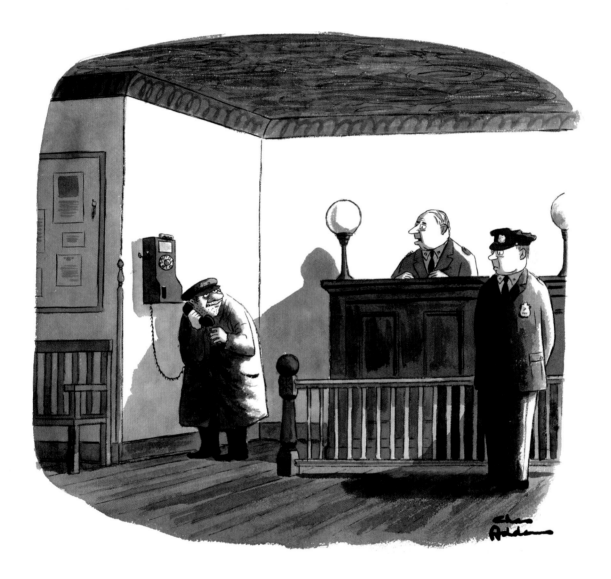

"When I said you were allowed one phone call, I did not mean another obscene one."

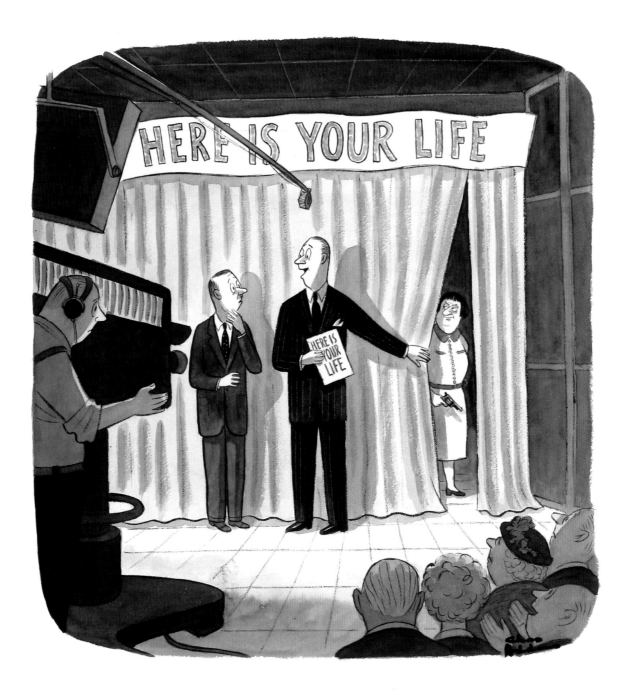

"...and now, George Pembrook, here is the wife you haven't seen in fifteen years."

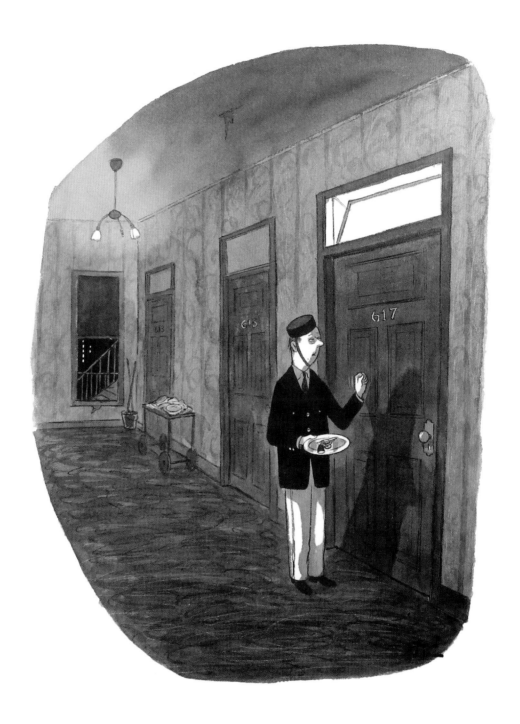

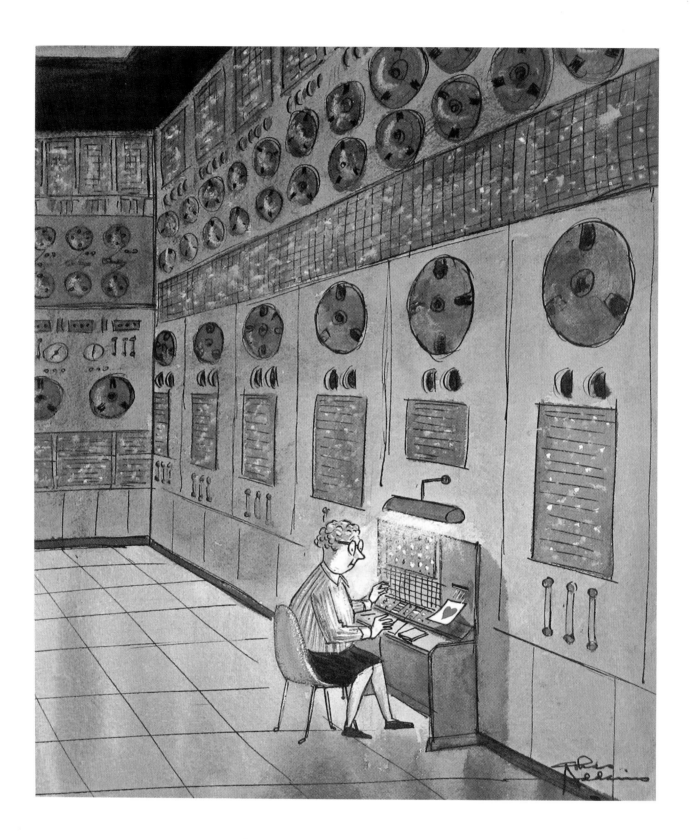

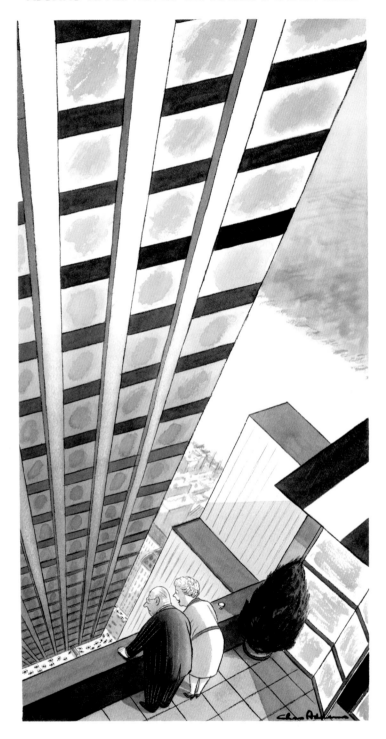

"You're right. That's exactly what they look like."

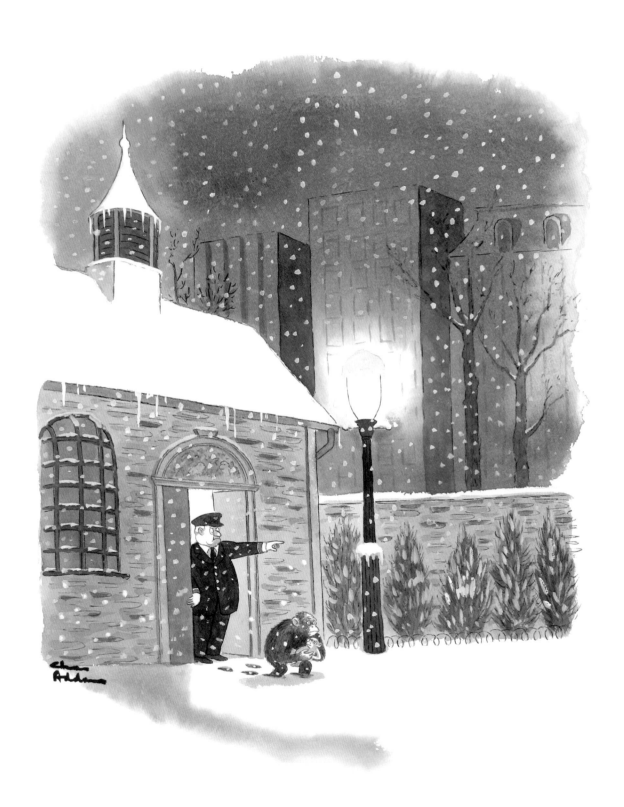

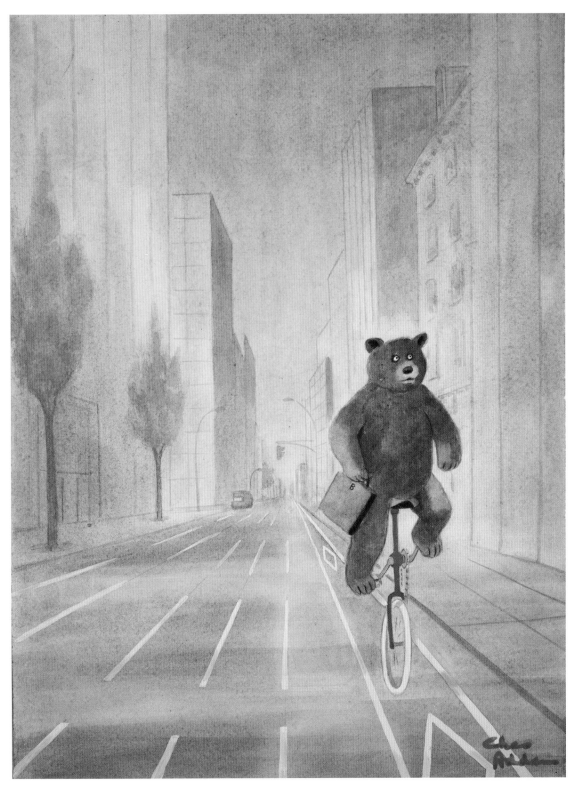

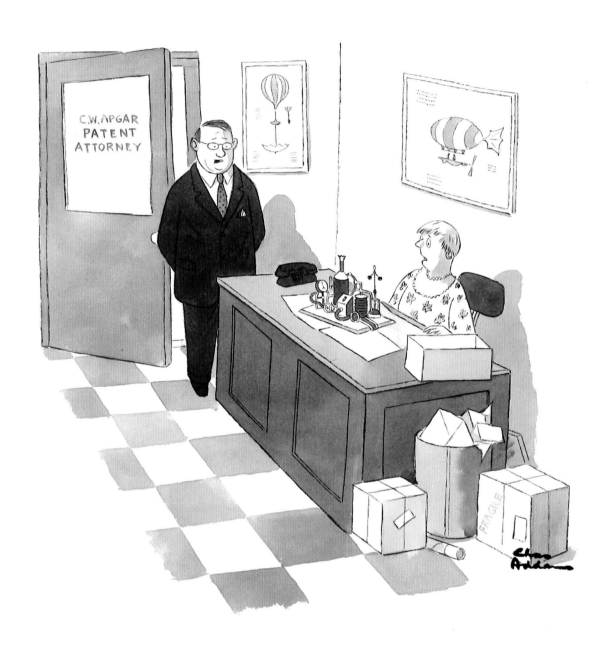

"Miss Benson, I wish you'd stop saying, 'What will they think of next?'"

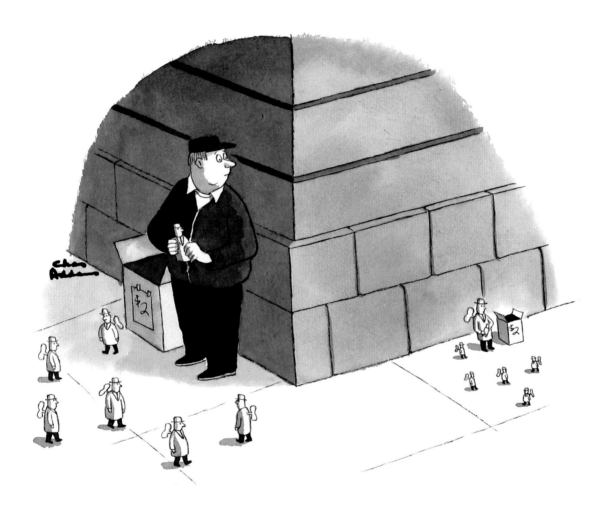

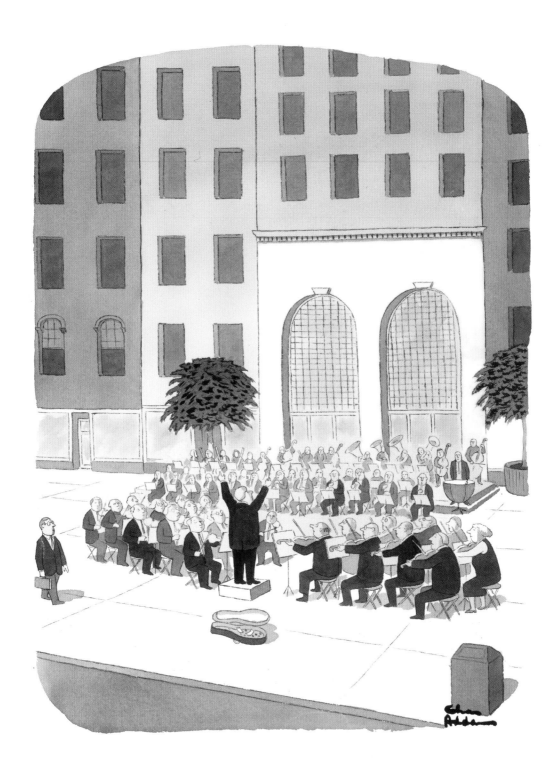

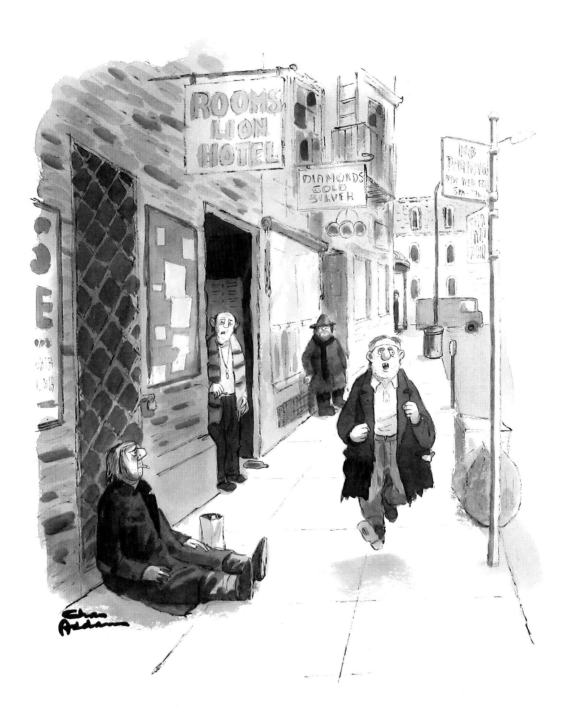

"What the hell's come over Monahan?"

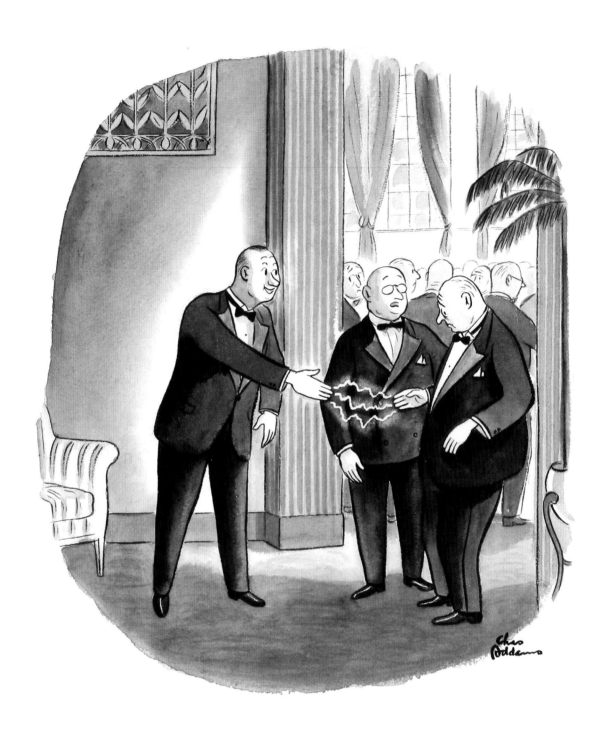

"Perkins, meet Fleming of Consolidated Power and Light."

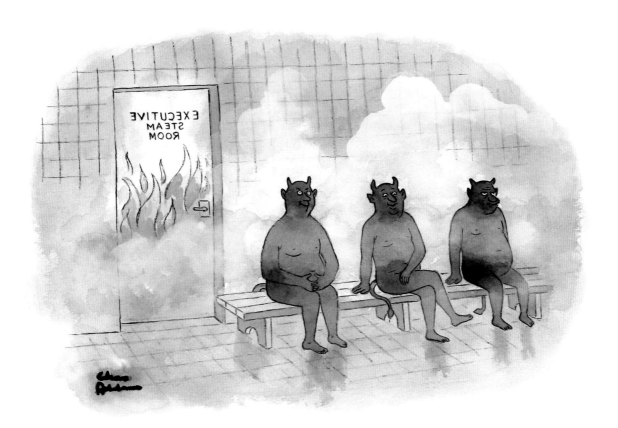

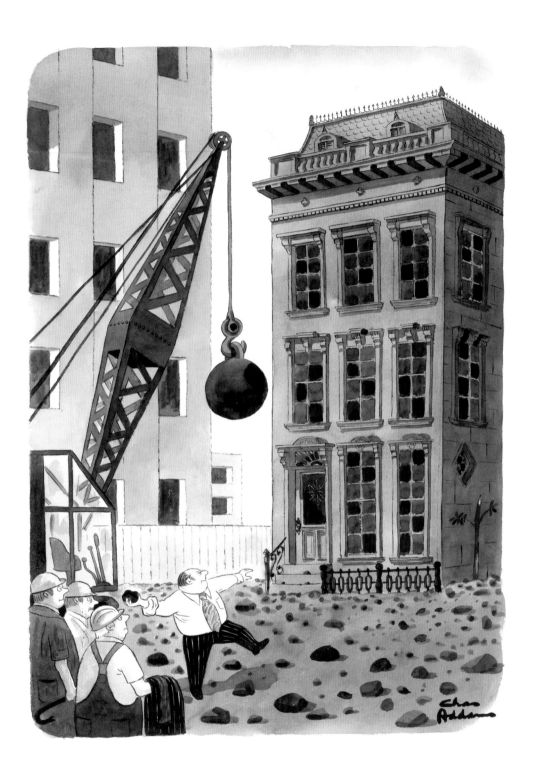

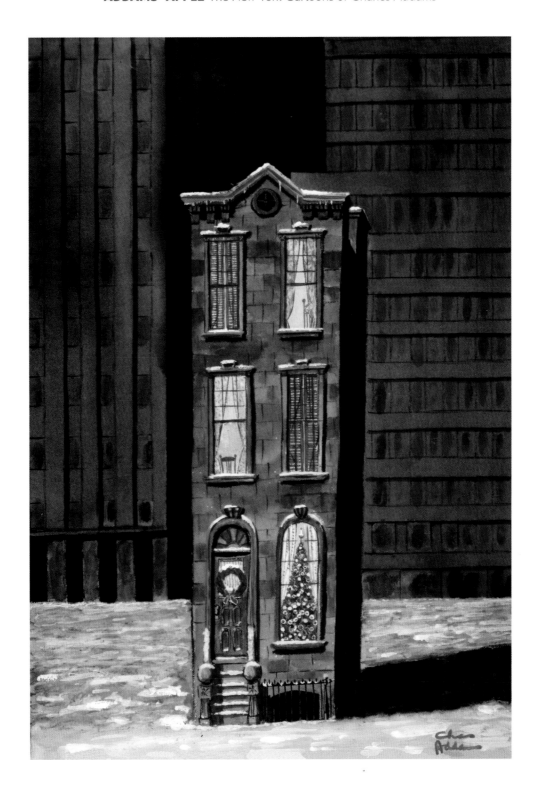

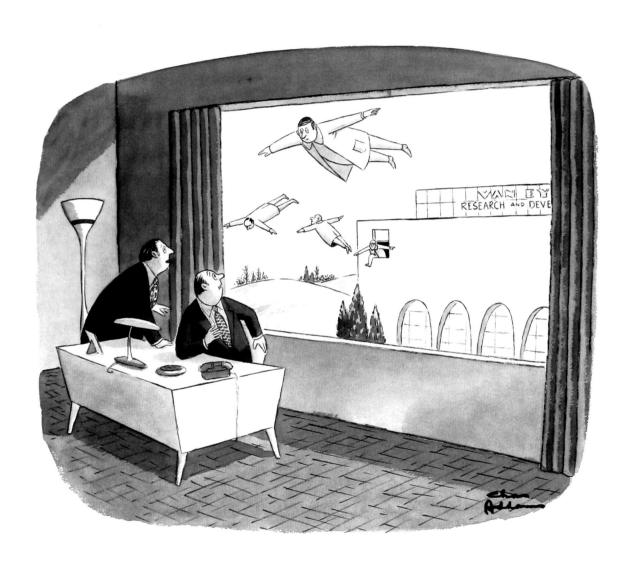

"Looks like R & D is into something big."

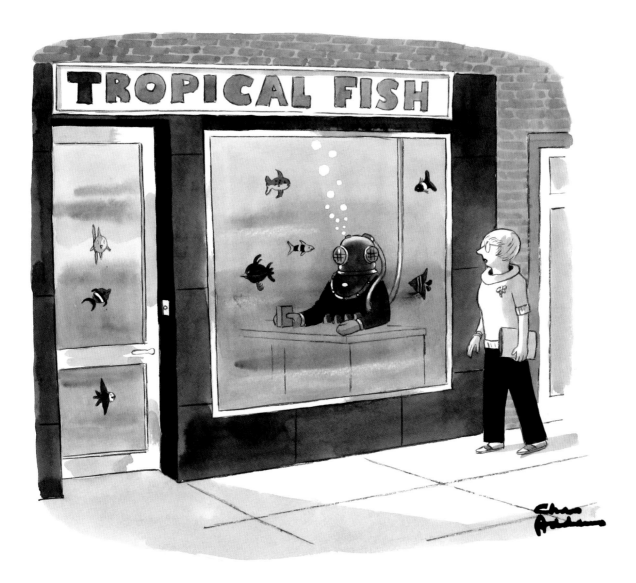

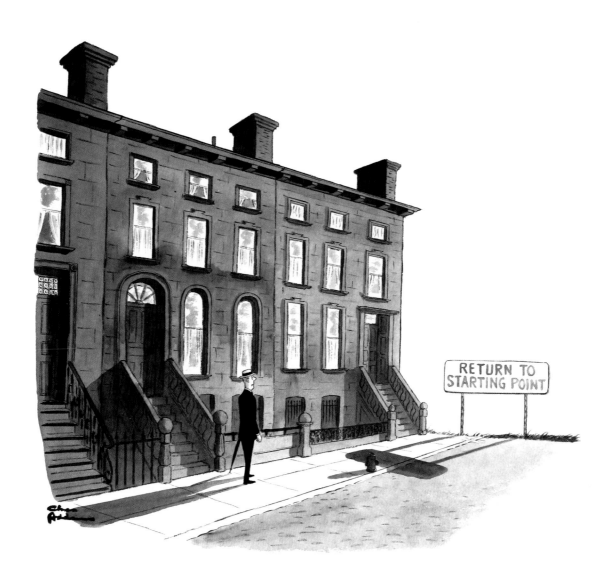

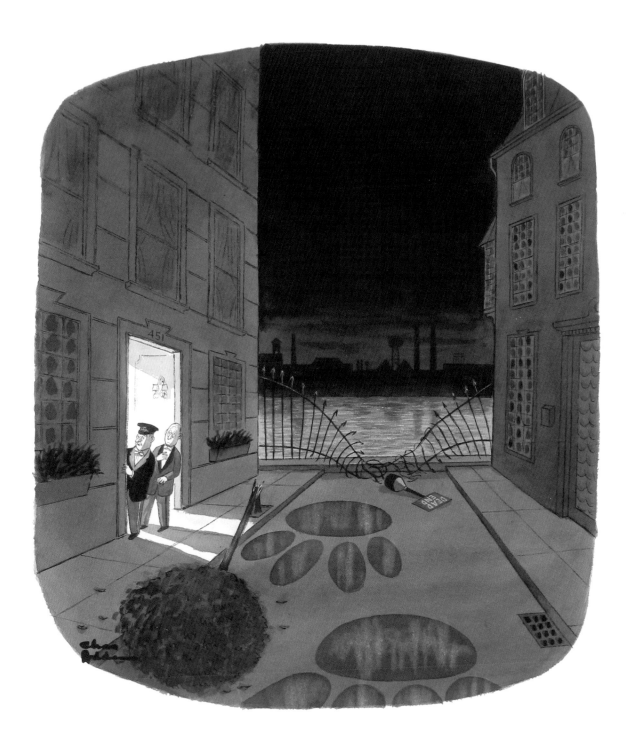

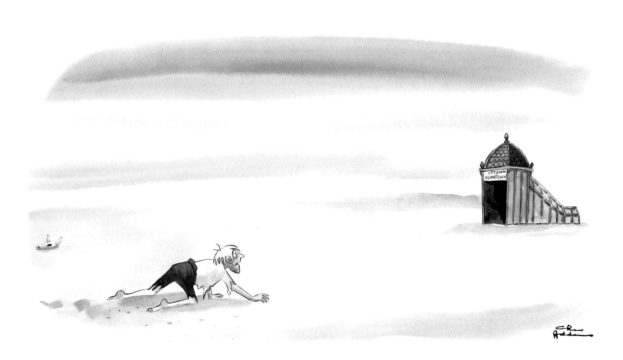

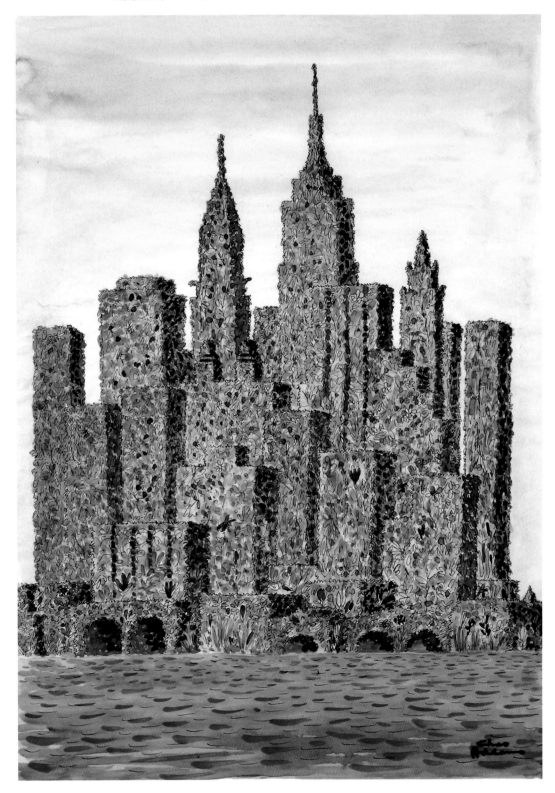

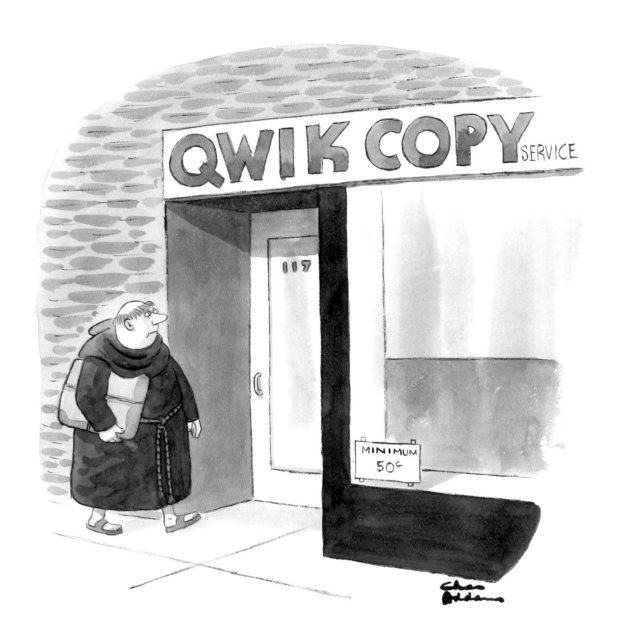

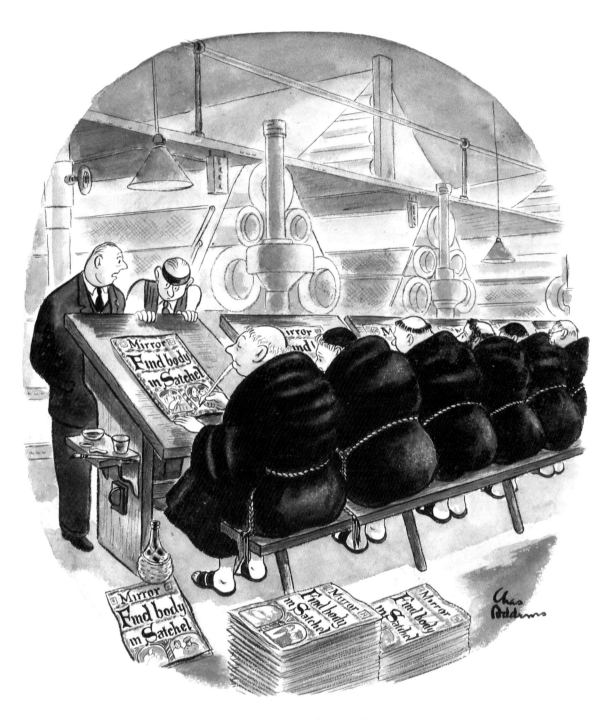

"They offered to help us out during the printers' strike."

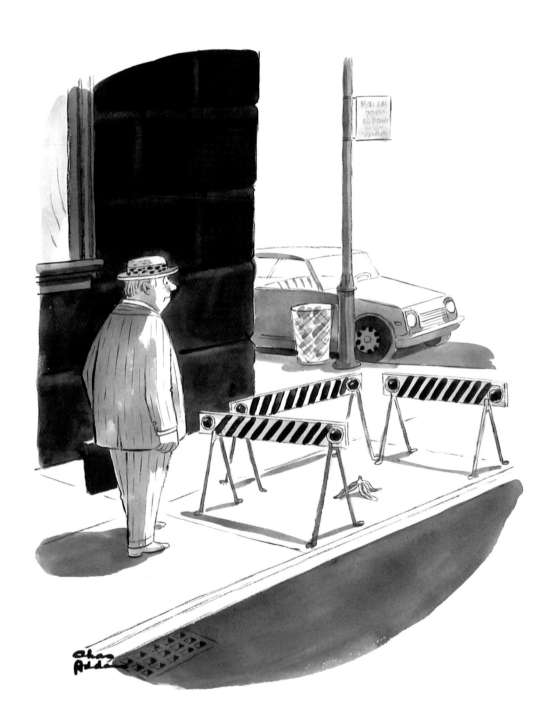

96

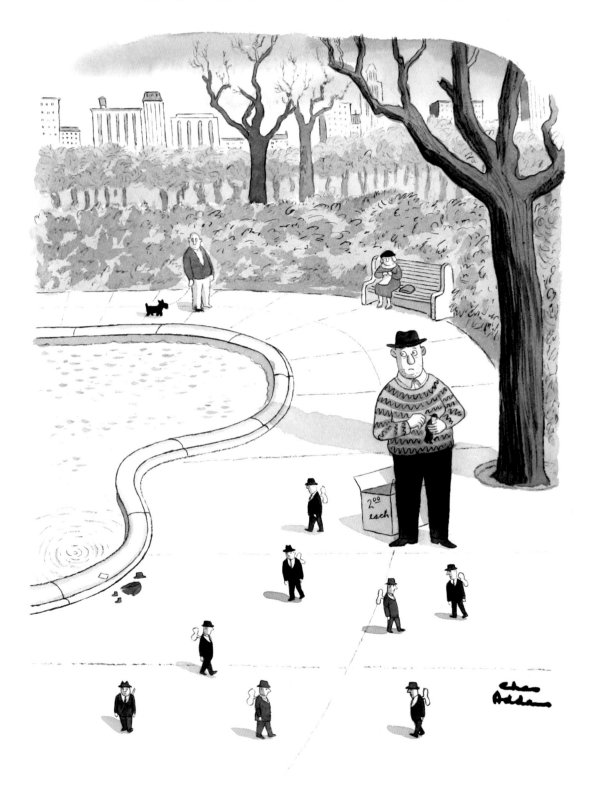

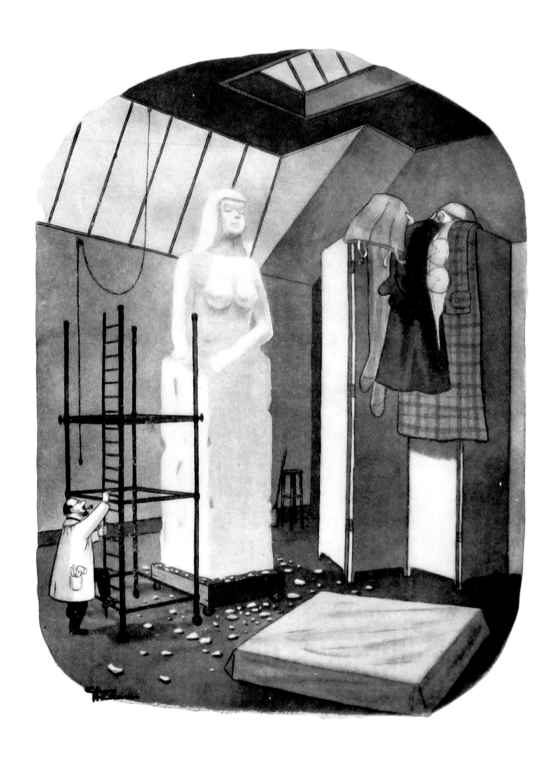

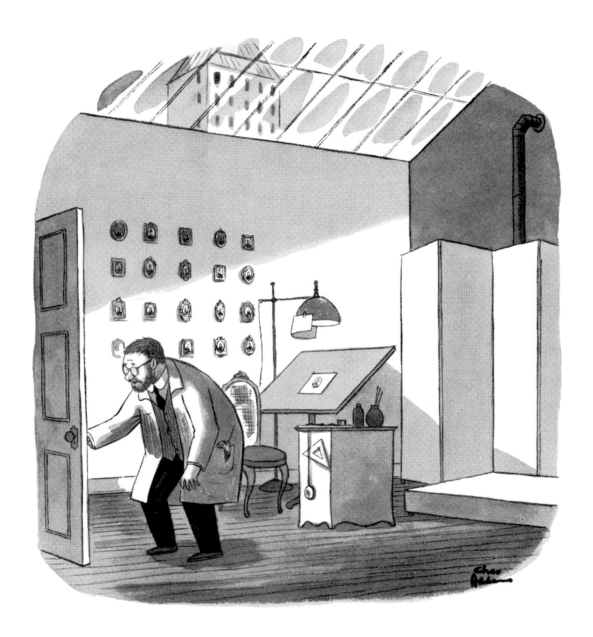

"Same time tomorrow, then, Miss Straley."

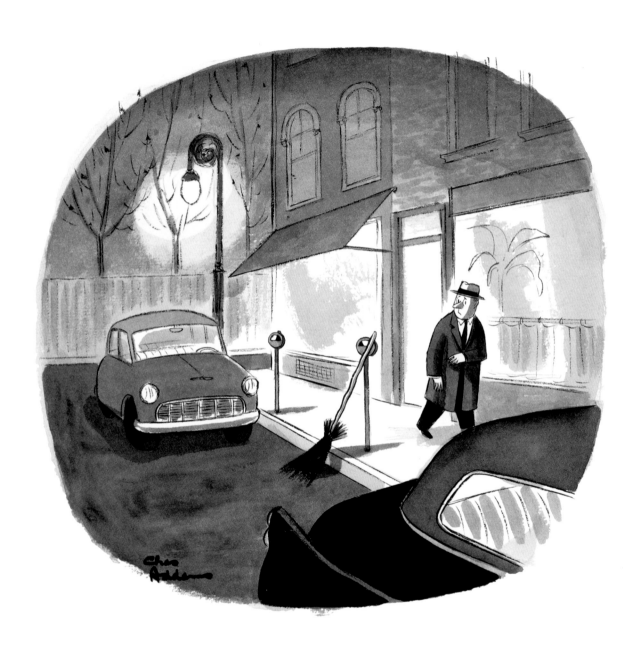

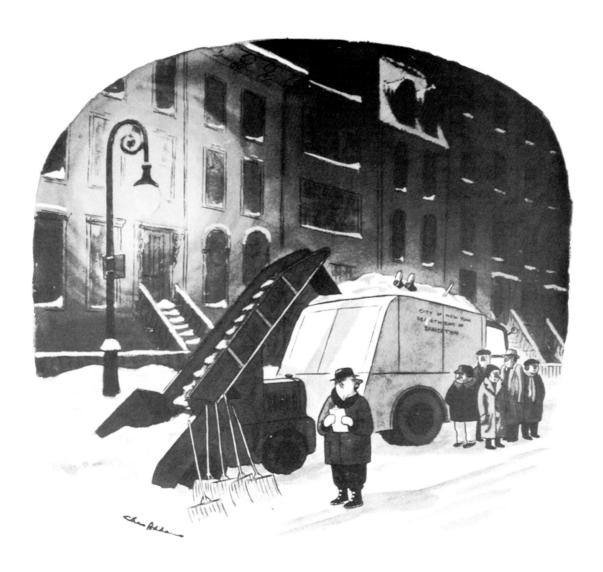

"Just a minute you guys – we're missing one shovel."

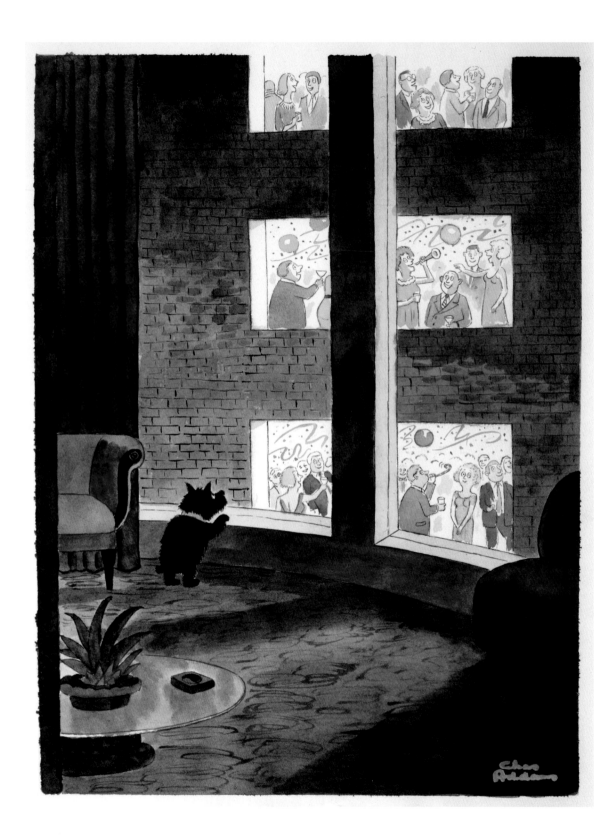

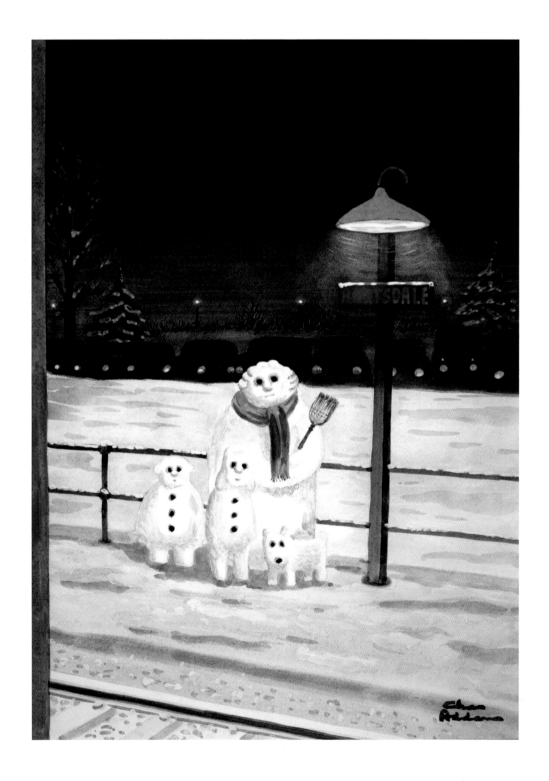

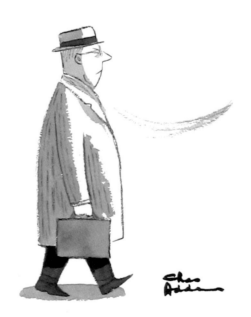

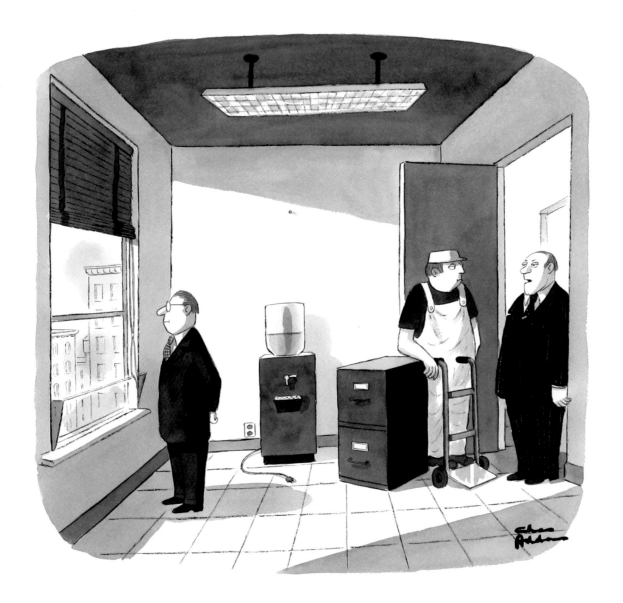

*"The file goes to the secretarial pool, the cooler goes to accounting,
and Mr. Hadlock goes to the office next to mine."*

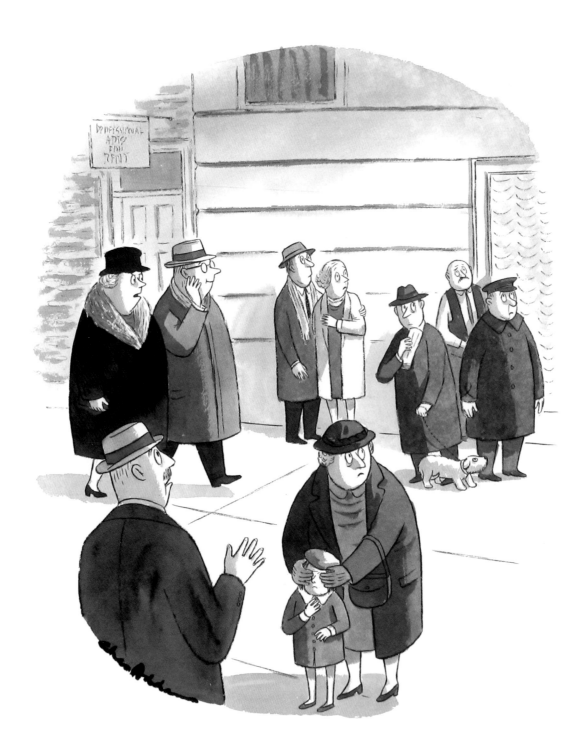

"You and your off-beat friends."

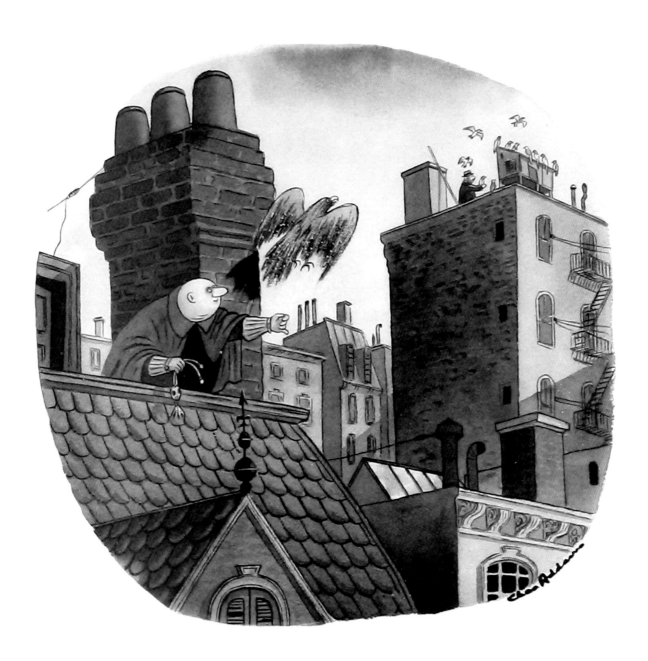

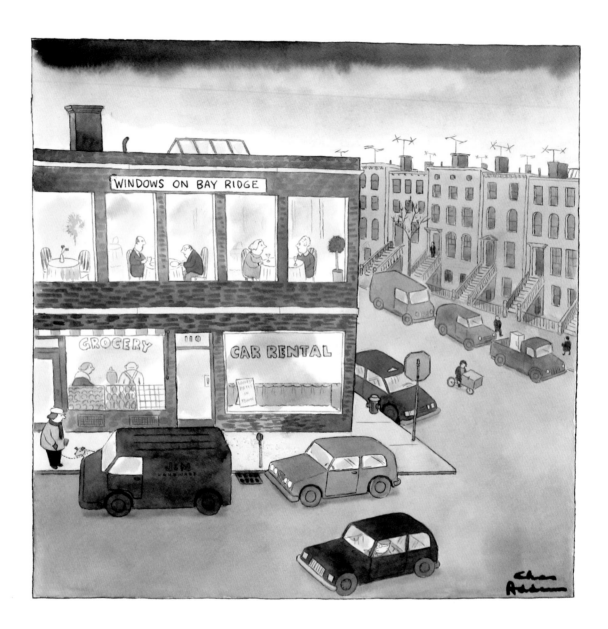

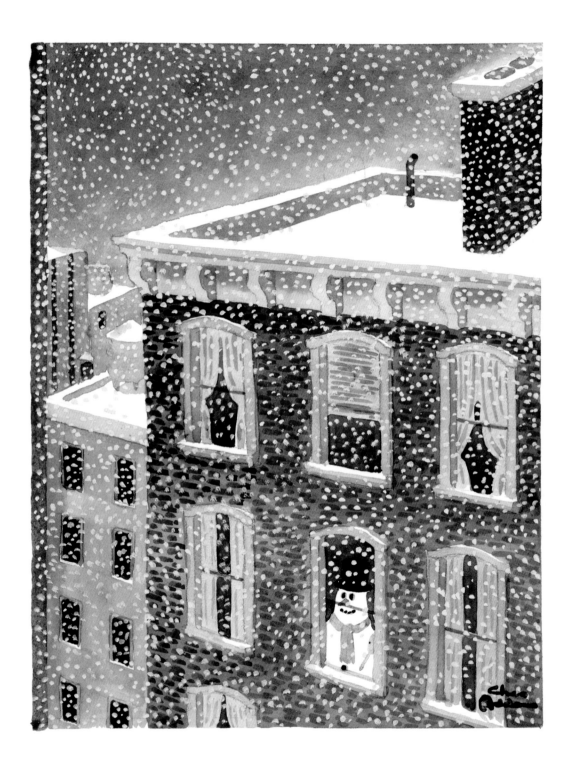

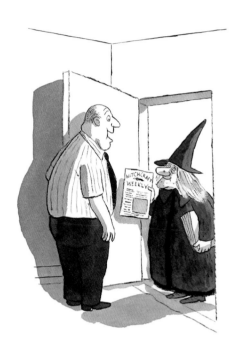

"'Witchcraft Weekly'! You've got to be . . .

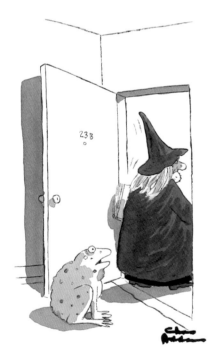

. . . kidding."

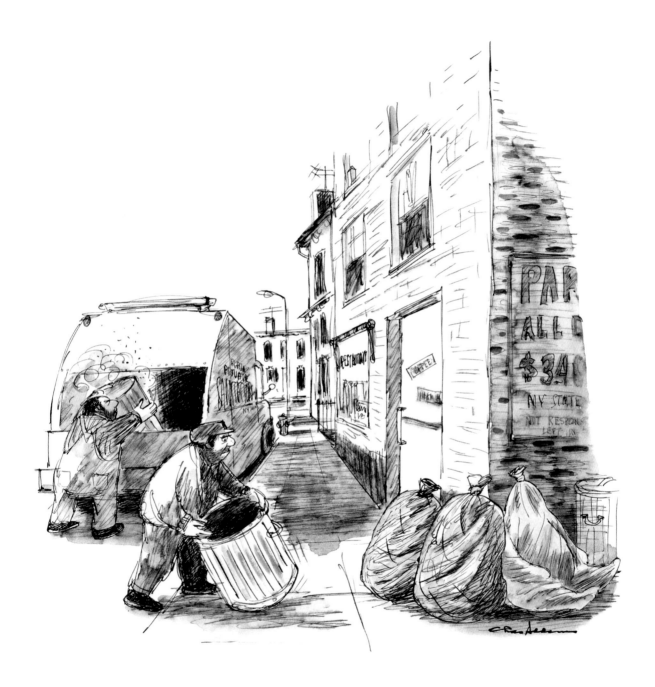

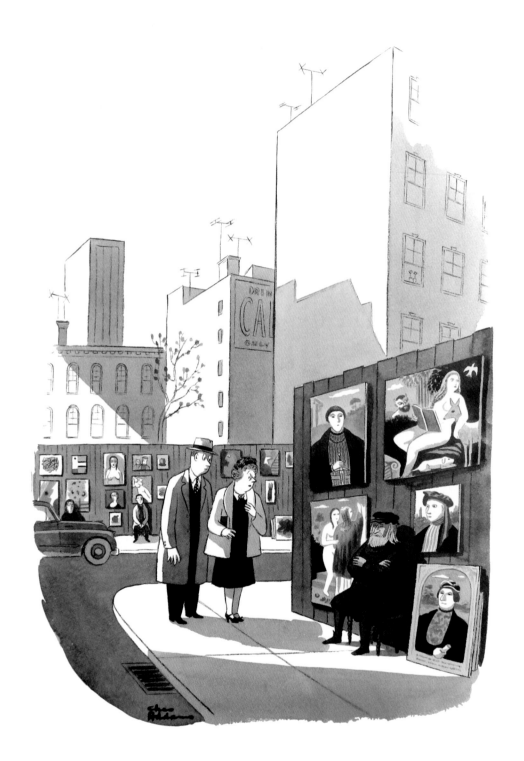

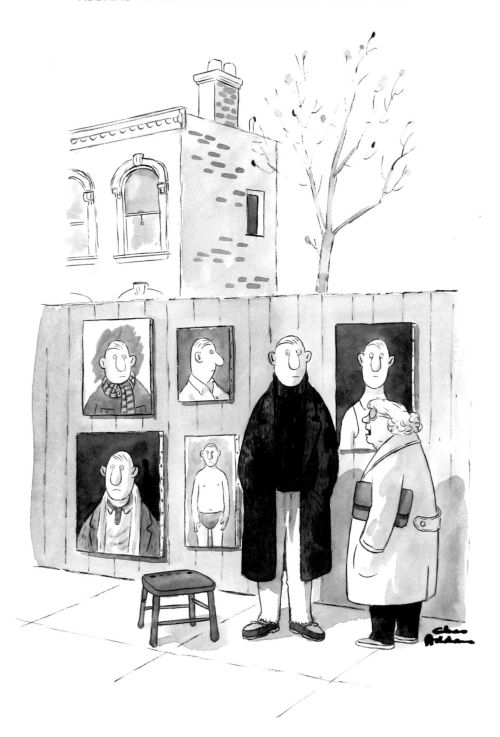

"This is all your own stuff, fella?"

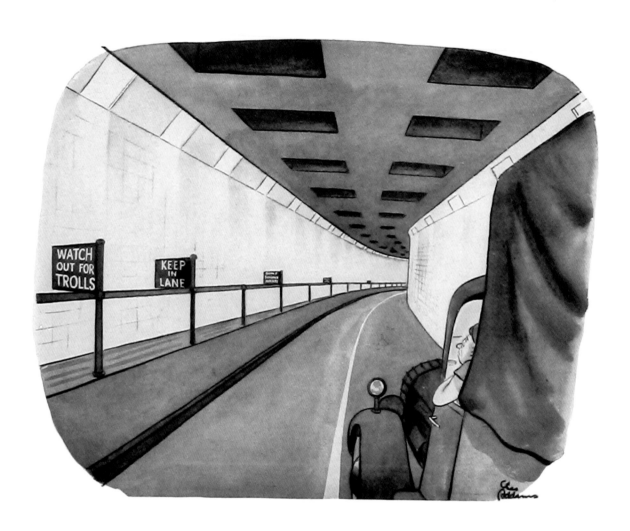

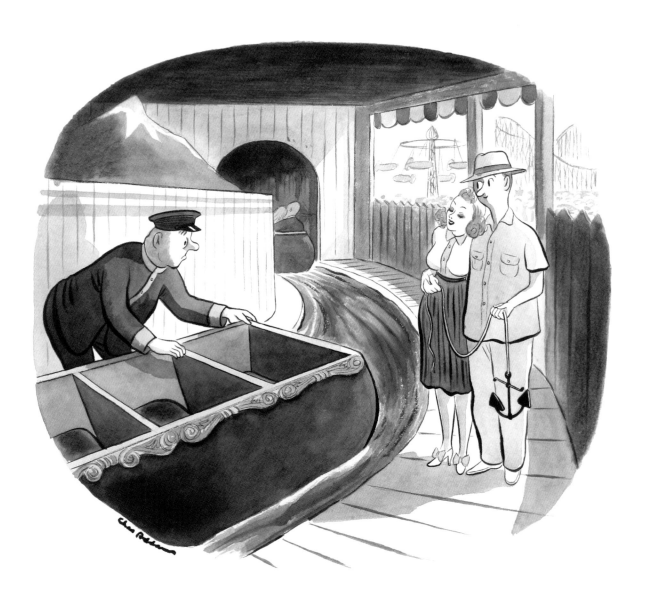

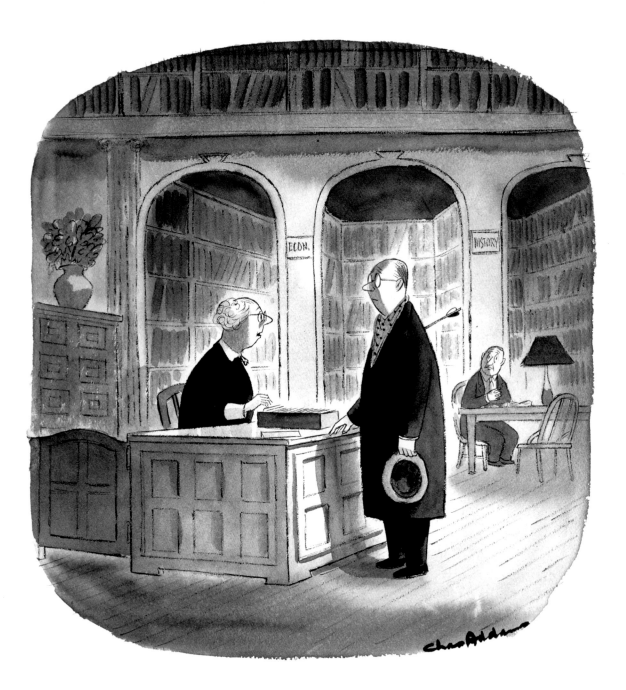

"I'm sorry, but our First Aid Manual is on reserve."

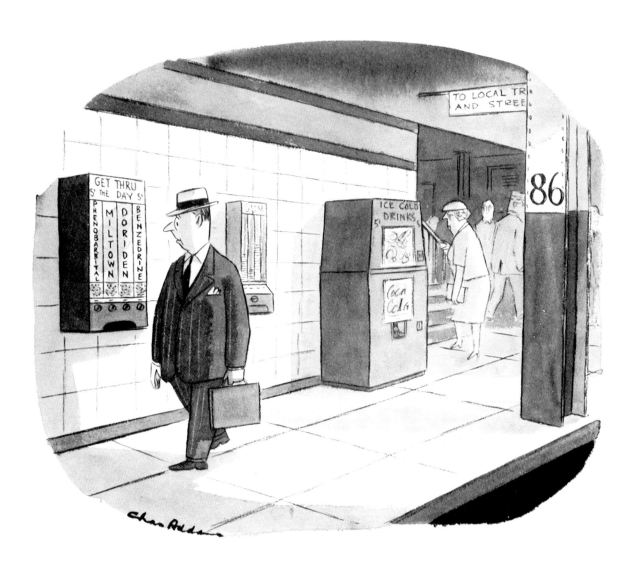

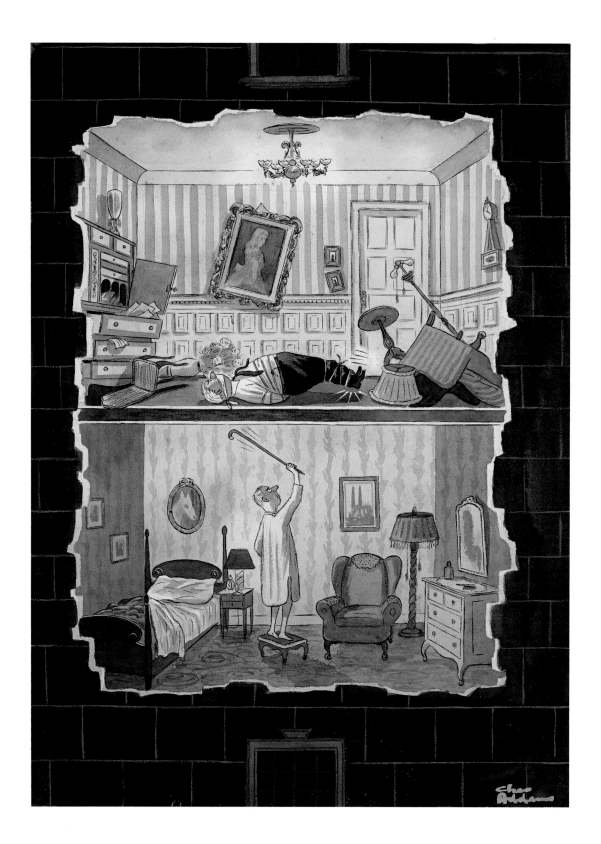

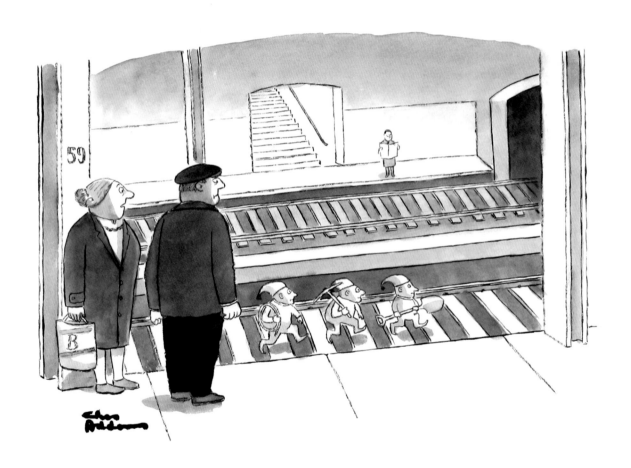

"The M.T.A. keeps trying, God knows."

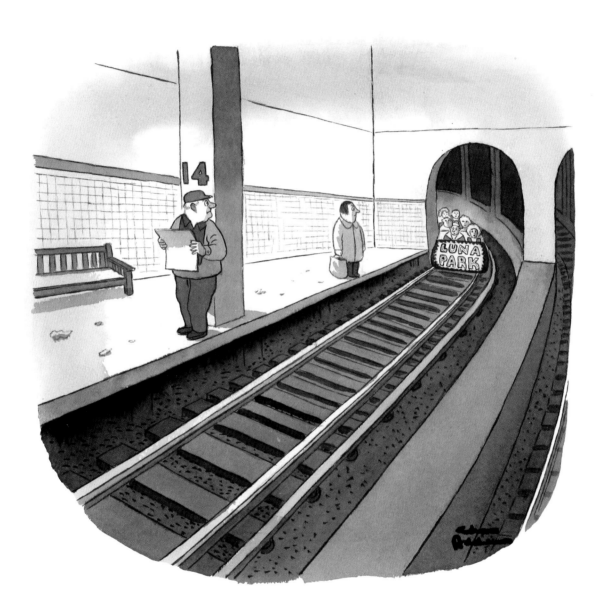

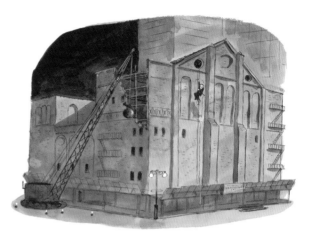

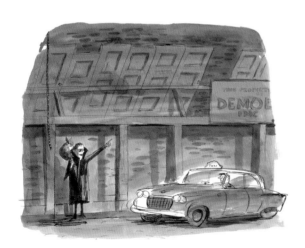

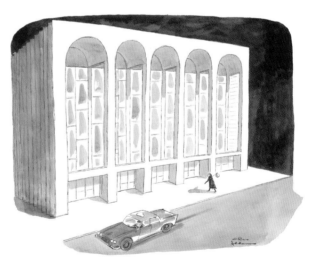

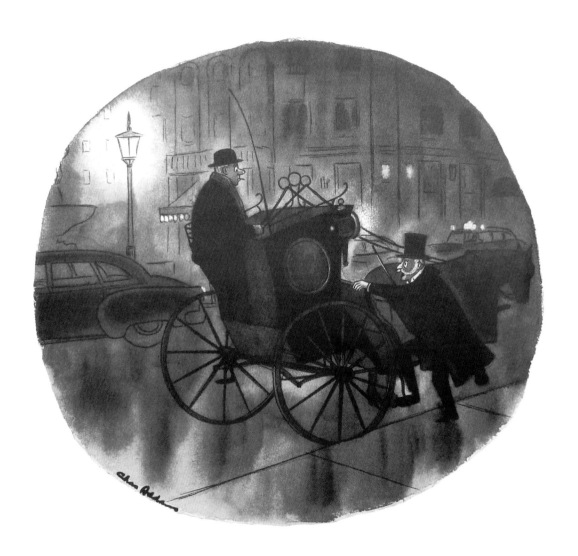

"Delmonico's – and hurry!"

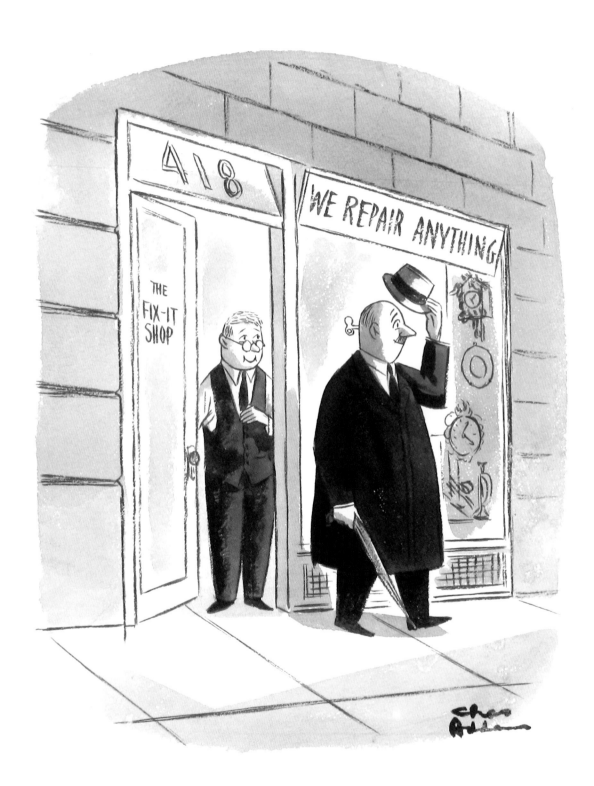

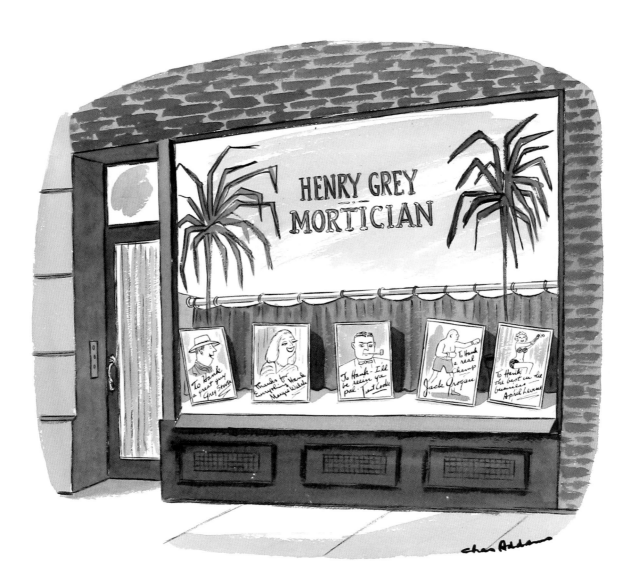

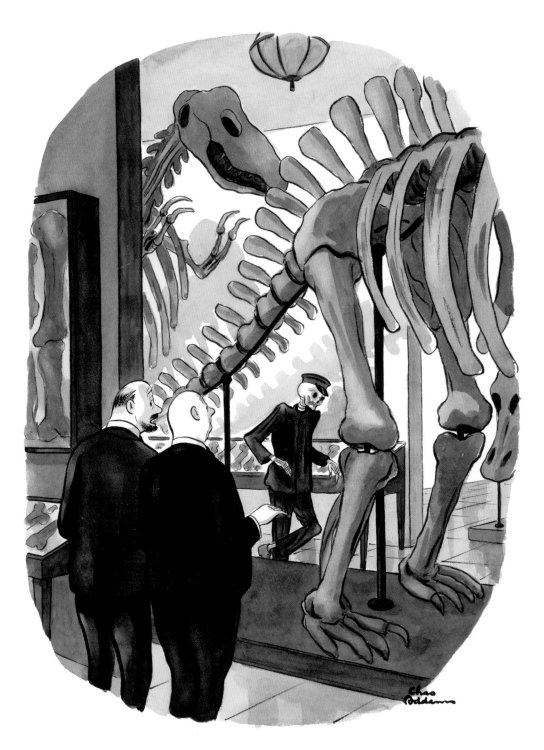

"Perhaps Comstock needs a vacation."

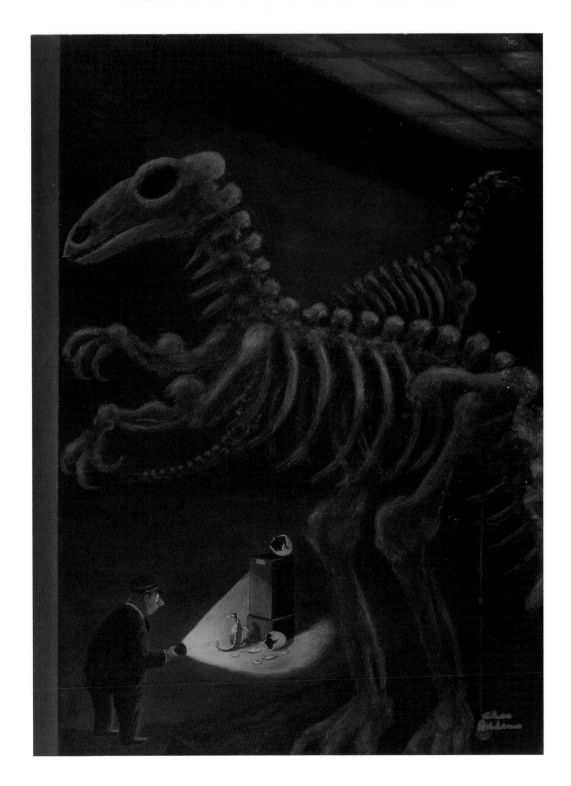

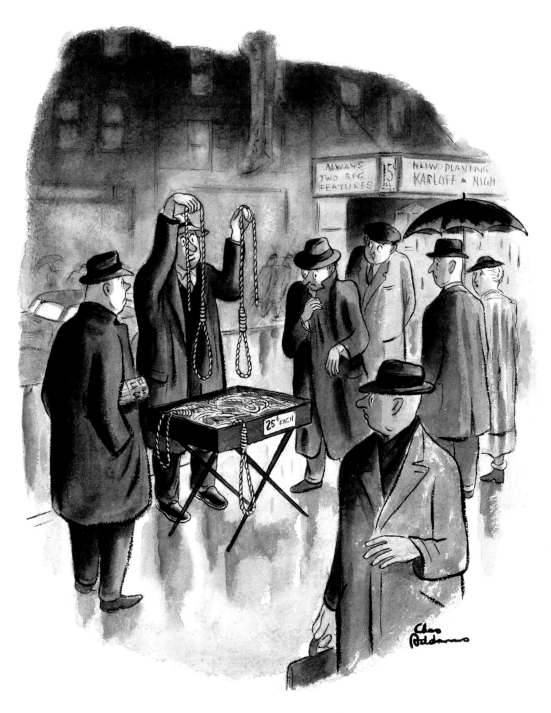

"In a rut, men?. . . Discouraged?. . . Life look hopeless?"

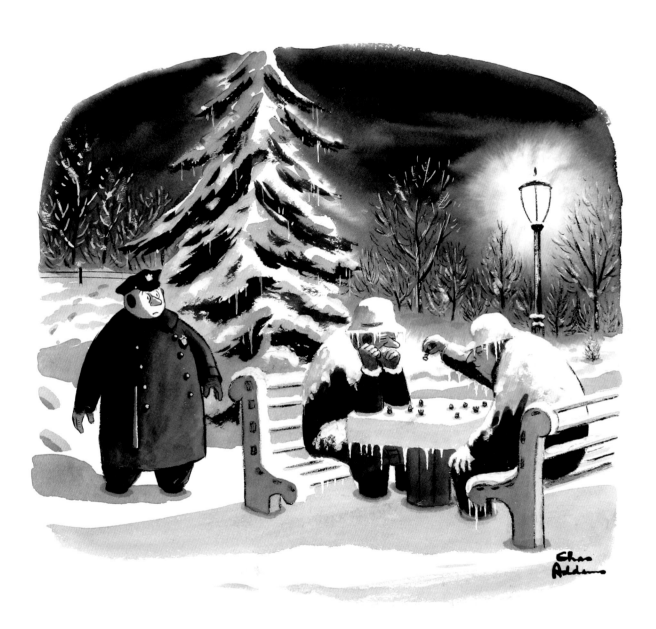

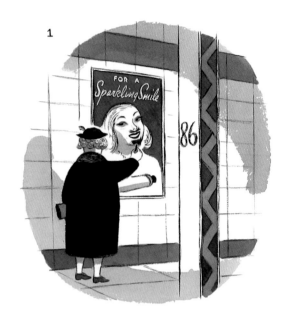

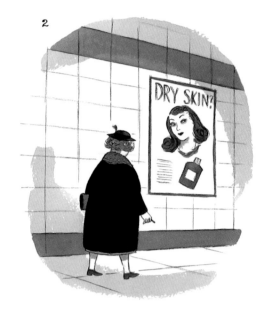

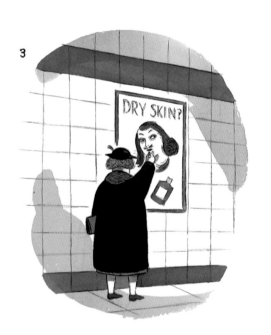

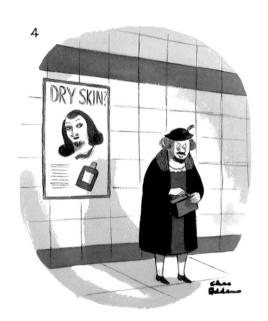

130

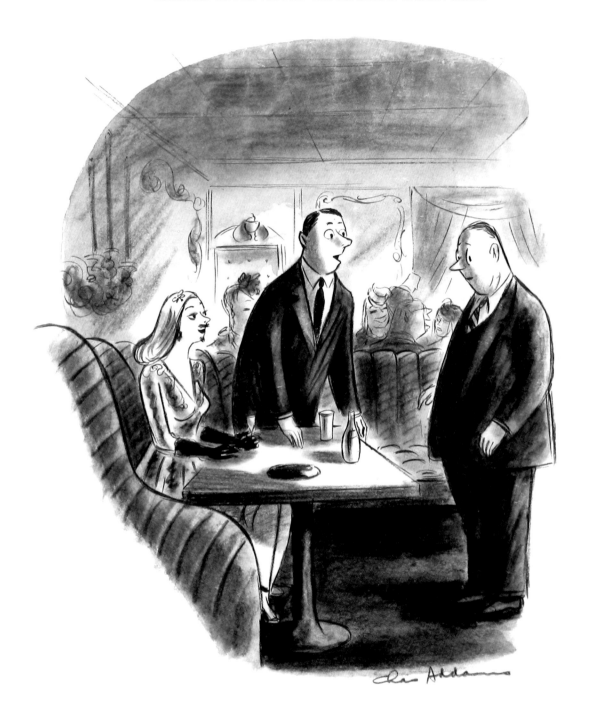

"Miss Osborne poses for subway posters."

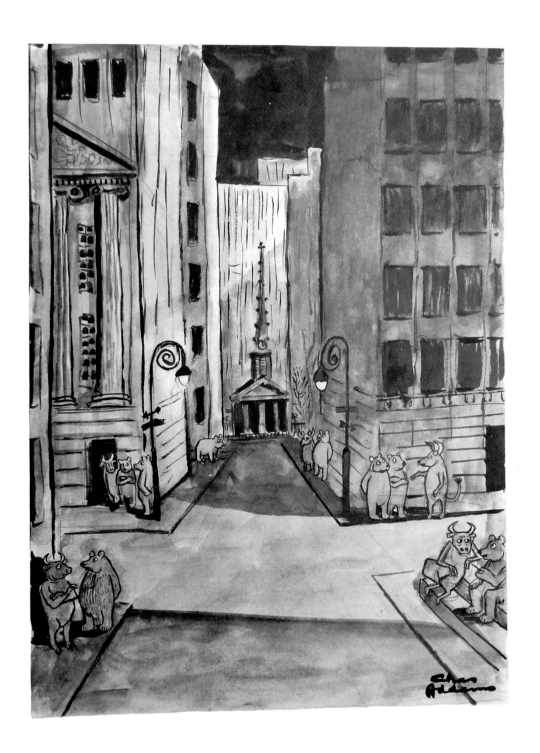

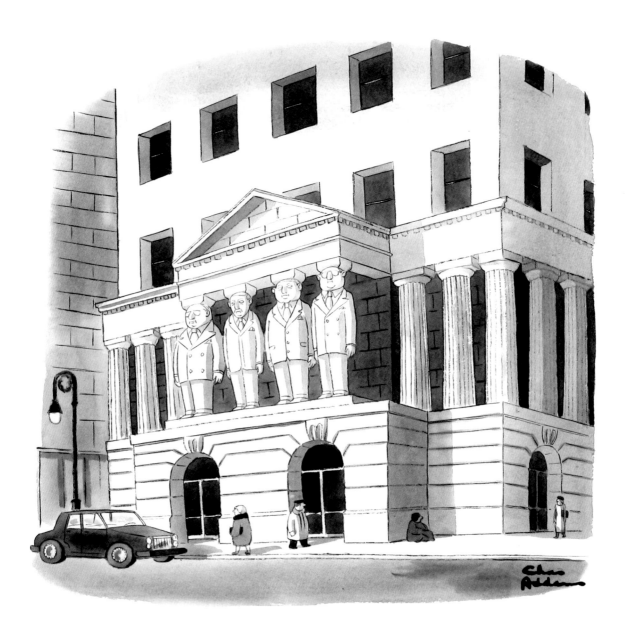

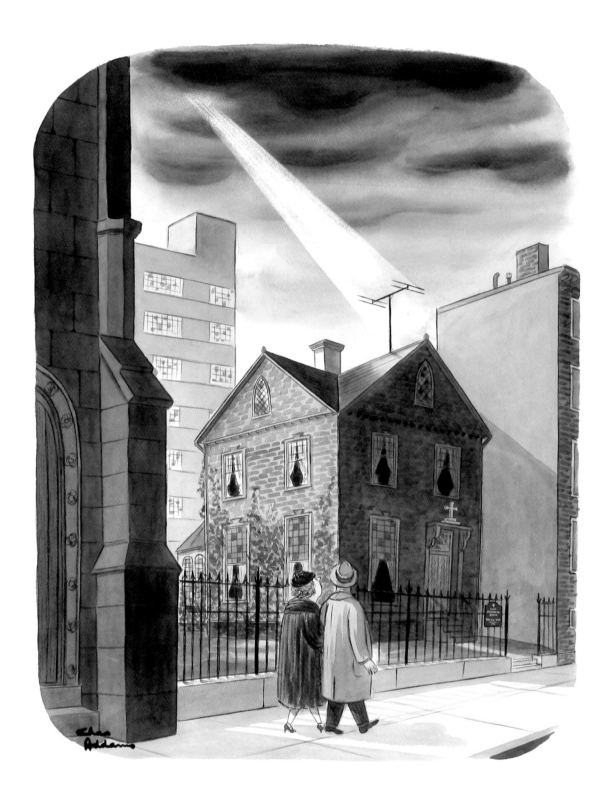

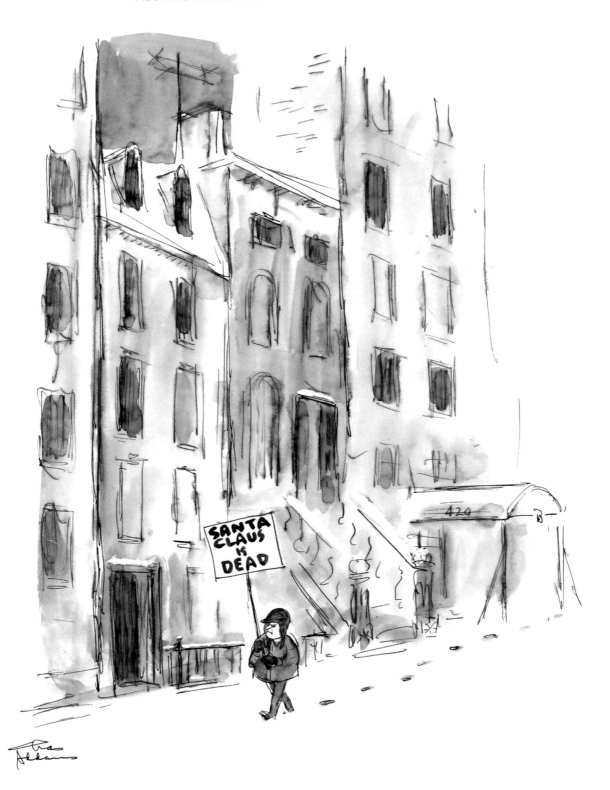

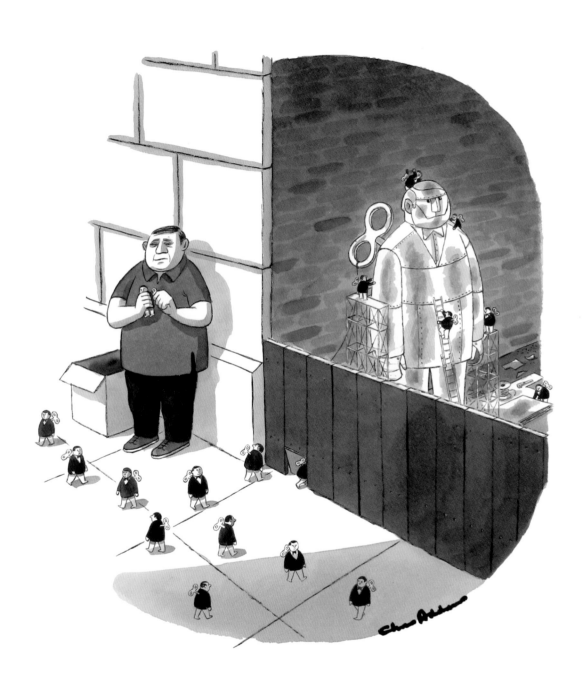

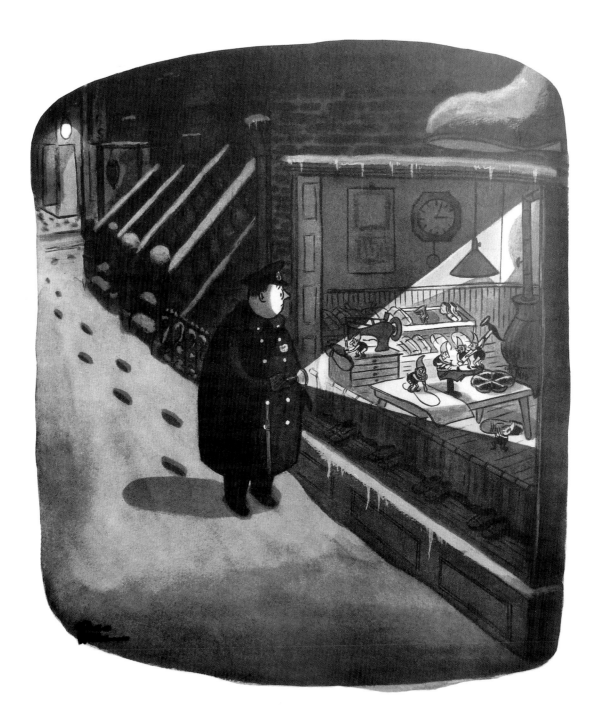

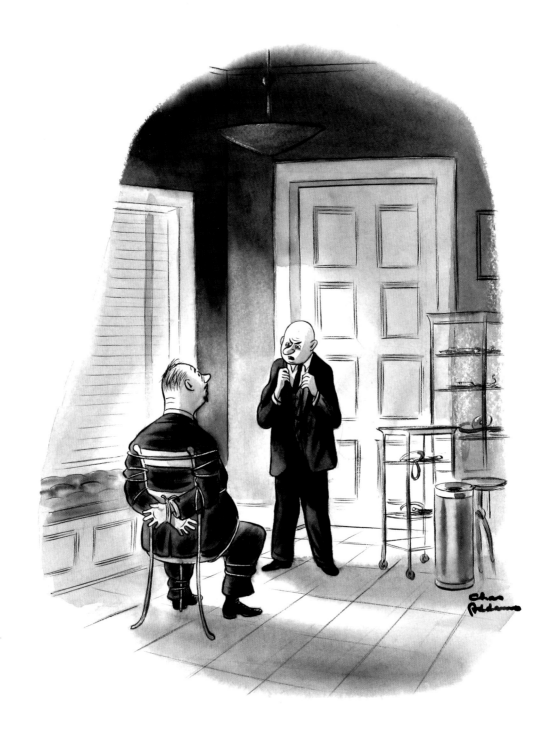

"Now tell me, Doctor, just when did you first begin to notice this paranoia of mine?"

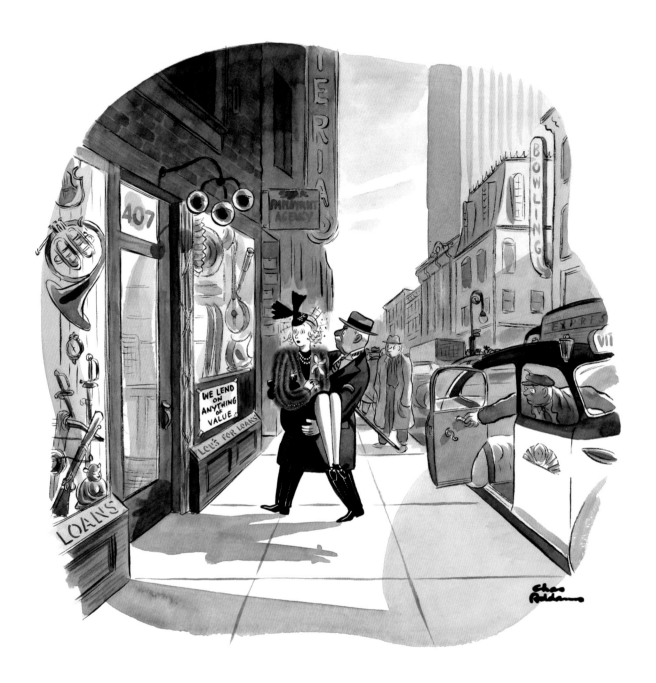

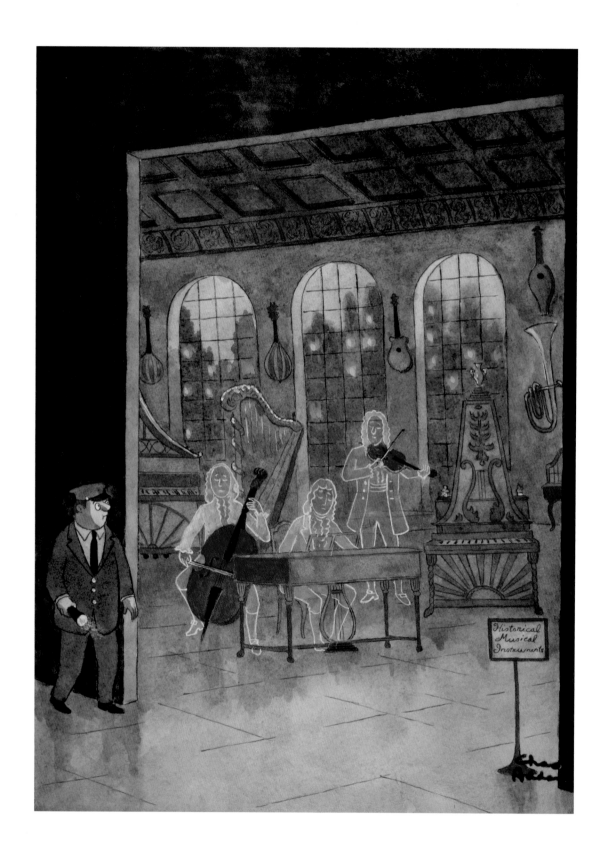

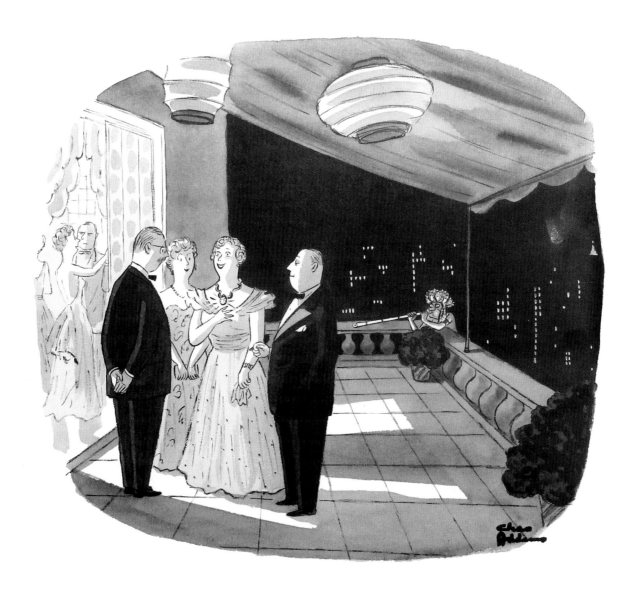

"There's an amusing little legend connected with it – something about a dreadful curse."

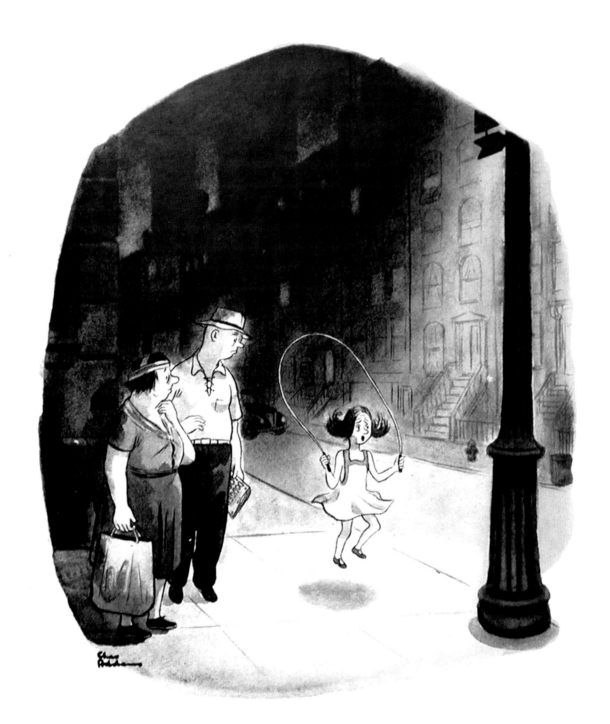

"Twenty-three thousand and one, twenty-three thousand and two,
twenty-three thousand and three ..."

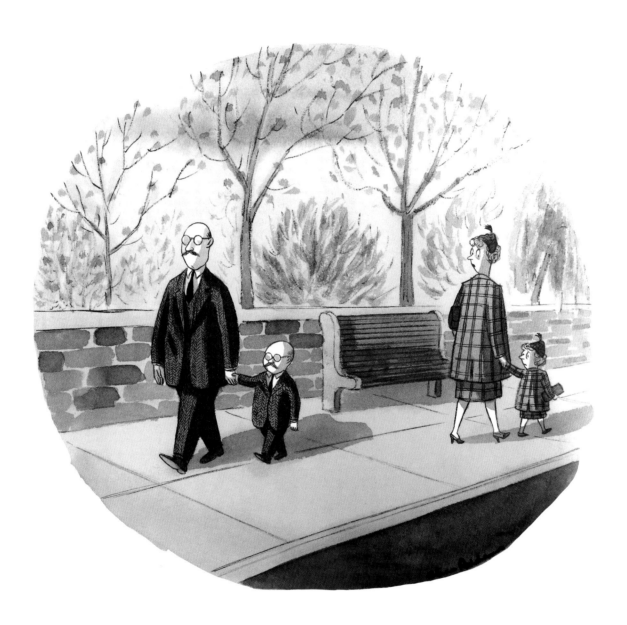

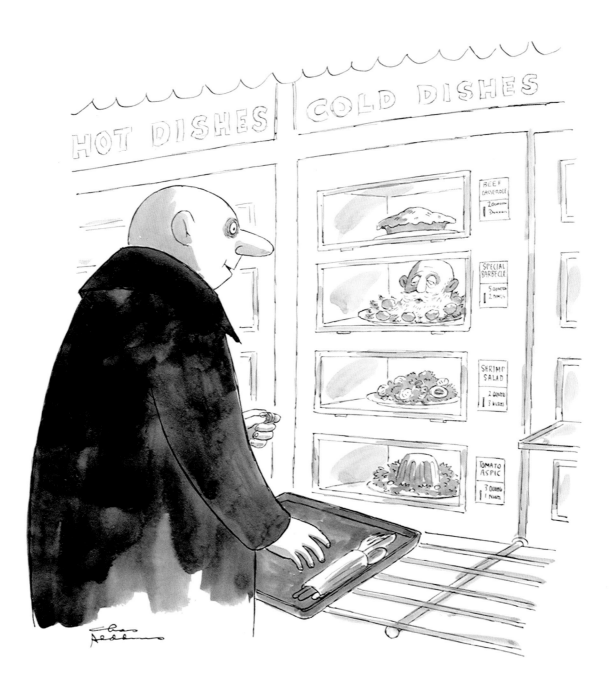

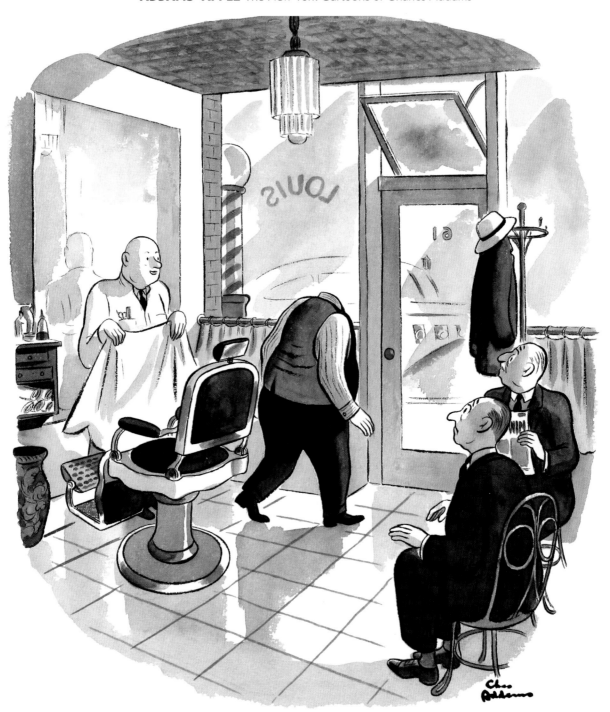

"Next?"

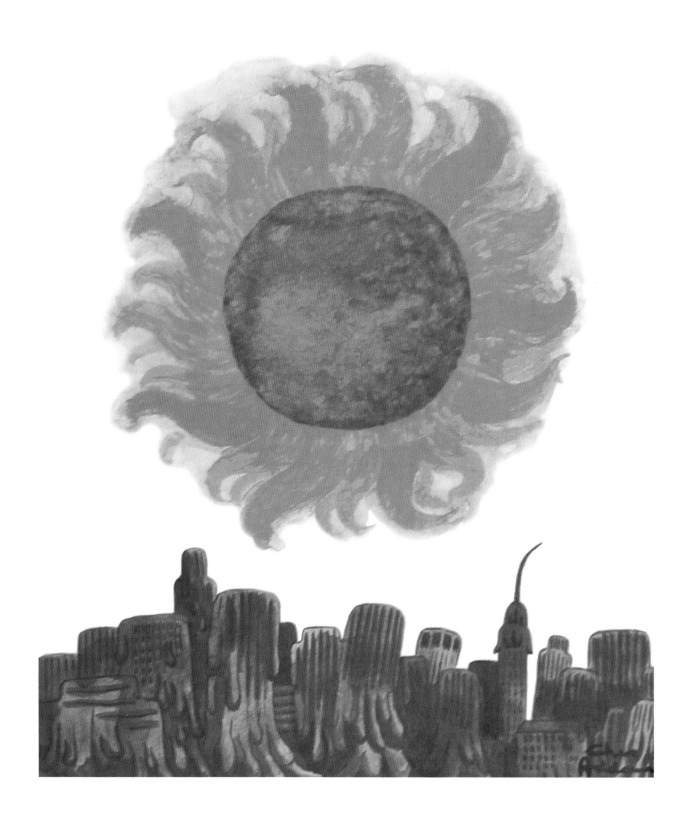

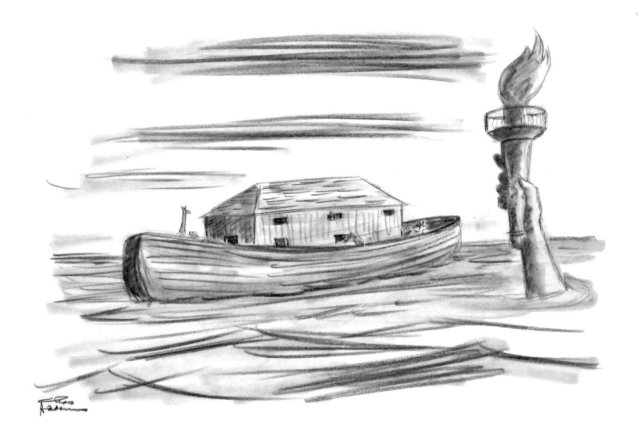

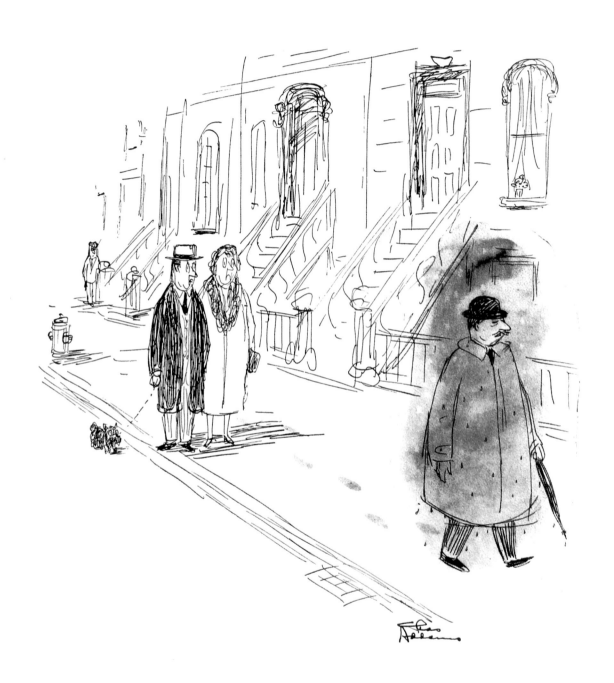

"Now, there goes an Anglophile if I ever saw one."

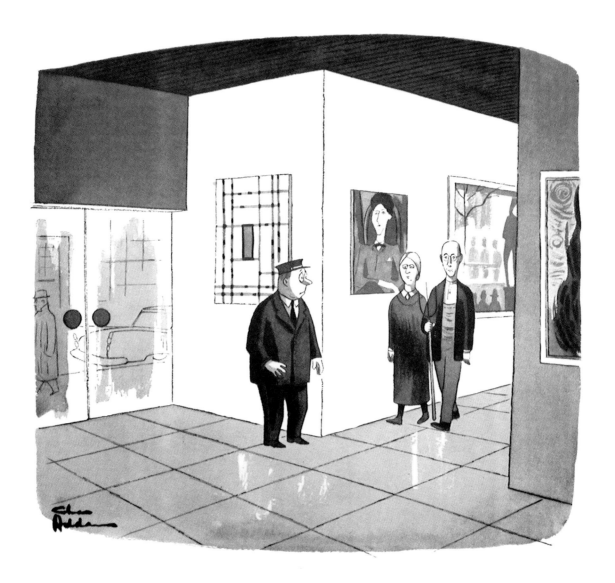

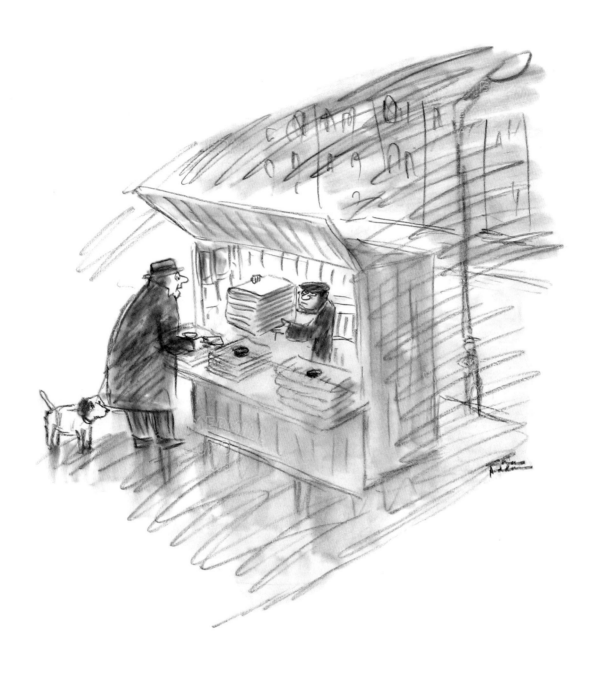

"Gosh! I never realized there was an unabridged Sunday Times!"

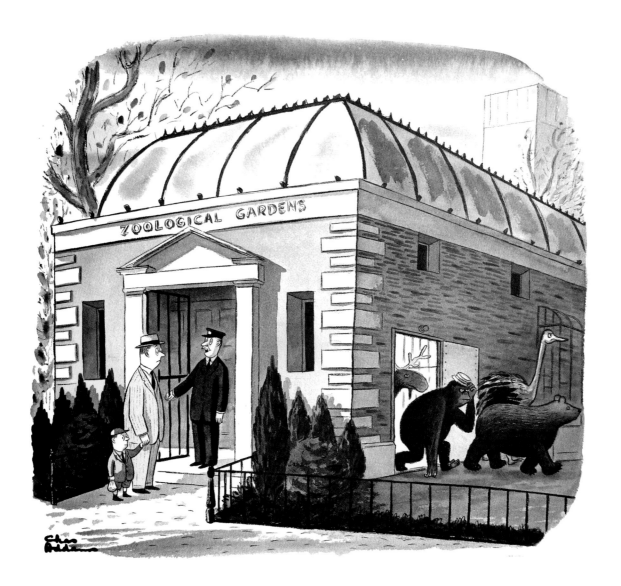

"Sorry, folks, we quit at five."

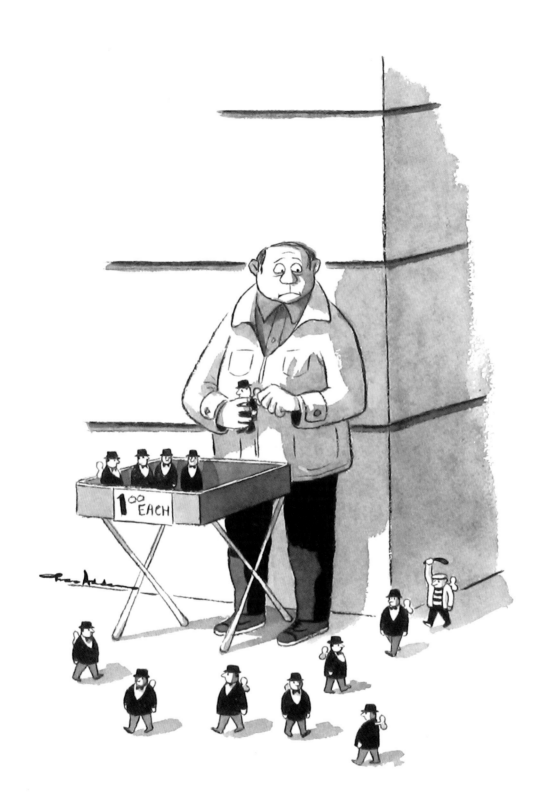

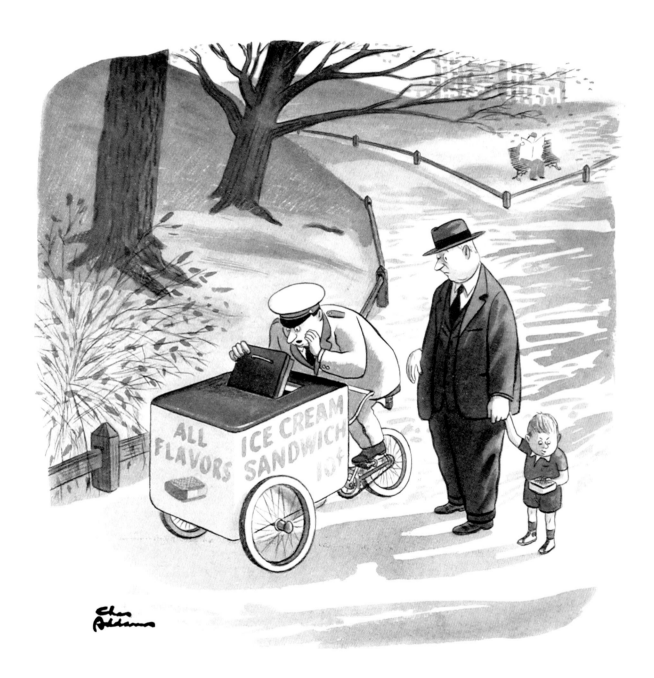

"Another vanilla, Benny."

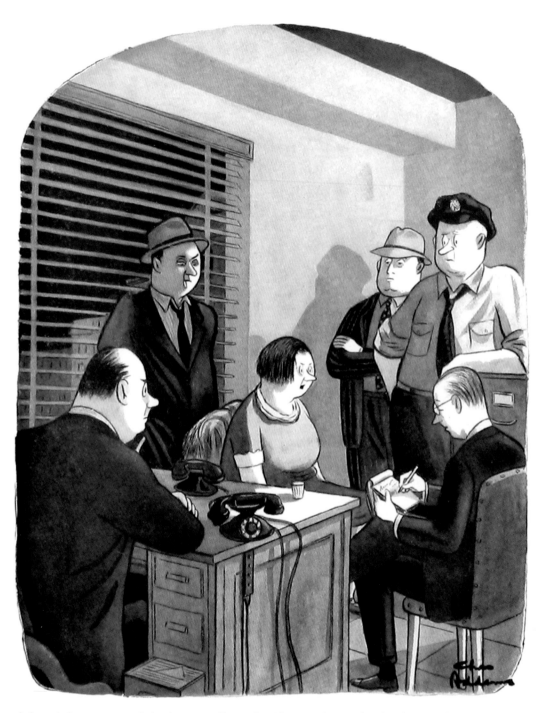

"… and then I disconnected the booster from the Electro-Snuggle Blanket and put him in the deep-freeze. In the morning, I defrosted him and ran him through the Handi Home Slicer and then the Jiffy Burger Grind, and after that I fed him down the Dispose-All. Then I washed my clothes in the Bendix, tidied up the kitchen, and went to a movie."

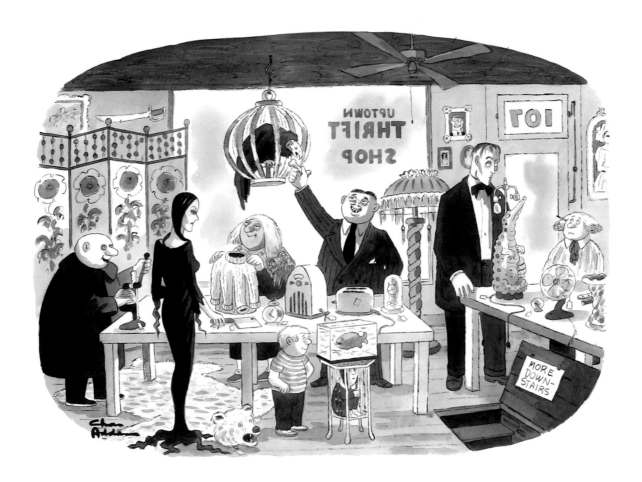

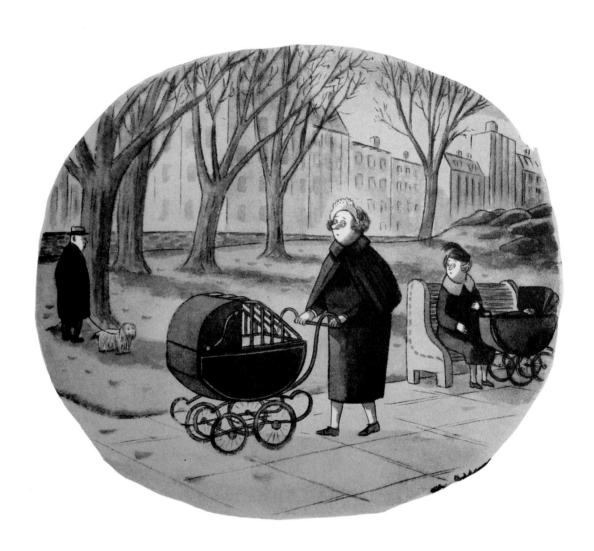

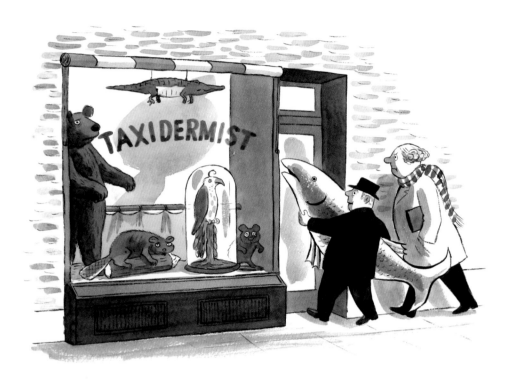

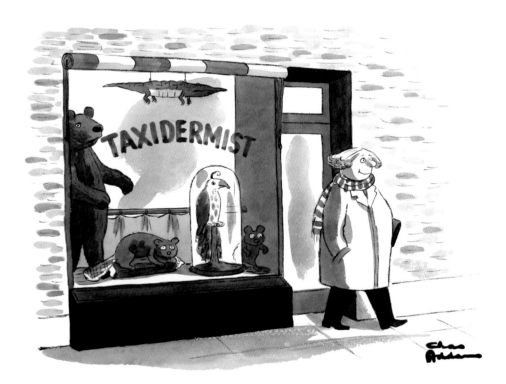

INDEX

List of Illustrations: Unless otherwise specified, the dates given are those of publication in *The New Yorker* magazine.